THE

BULLET JOURNAL

for beginners

Karen Lancaster

Art-e-fact

10 9 8 7 6 5 4 3 2 1

CONTENTS

	page
Introduction to the Bullet Journal	5
What is a bullet journal?	5
Is bullet journaling for me?	6
What should my BuJo look like?	6
What materials do I need?	7
Getting started	8
Jargon buster	8
Key to symbols	9
It's time to start!	9
About the layouts in this book	10
Remember!	10
So you want to start a bullet journal?	11
What are the most important parts of the BuJo?	12
Concerns and questions	13
Layouts:	
Future Logs	14
Monthly Logs	28
Two Weekly Logs	44
Weekly Logs	48
Daily Logs	86
Miscellaneous Pages:	
Ideas for your Bullet Journal Daily Logs	90
Corners and arrows	91
Banners for dates and titles	92
Icons	95
Fonts	96
Birthdays	98
Books	100

Level 10 life 102
Exercise and diet logs 106
Monthly review 111
Ladytime trackers 112
Financial and savings logs 114
Wedding 116
Summer fun 118
KonMari method 119
New year's goals 120
Keys 121
Page ideas for your bullet journal 122
Stickers used in this book 124
Useful physical resources 125
Useful online resources 126
References and further information 128

INTRODUCTION TO THE BULLET JOURNAL

The digital age has many perks, such as the ability to manage your life from your phone, tablet or computer; whether at your desk or on the move, there's an app for everything. There are separate apps for tracking your weight, budgeting, birthday wishlists, recipes to try – yet there is still something enduring about putting pen to paper.

But paper has its own problems: we can find ourselves noting things down on bits of paper (and if you're anything like me, misplacing them), and losing track of what information is written where.

Maybe you'd like to say goodbye to the disorganized scraps of paper, sticky notes on the fridge, and highlighted dates on the wall calendar? With a bullet journal, you can, because everything will be in one place.

What is a bullet journal?

A bullet journal is a planner / diary / to do list – or indeed anything else you want it to be. The idea was created by Ryder Carroll, and has been increasing in popularity since 2015. Carroll described the bullet journal is "an analog system designed to track the past, organize the present, and plan for the future".

In simple terms, a bullet journal is a notebook, into which you write whatever you feel like. What makes a bullet journal different from any notebook you might have previously used, are the following:

- There are a number of conventions and codes which are commonly used to simplify what is written in the notebook

- Bullet journaling has a large and evolving online community, with people sharing their ideas across multiple platforms, including Instagram, Pinterest, Facebook, Twitter, and blogs

- The content of a bullet journal is often more decorative and pleasing to look at than your average notebook

- When people have used up all the pages in a notebook full of shopping lists and scribblings, they may just throw it in the trash; people are far more likely to hang onto their bullet journals, as a memoir of sorts

Is bullet journaling for me?

Ask yourself these questions:

- Do I want to be (more) organized?

- Would I like to keep a journal, but feel I just don't have the time?

- Do I want to avoid having multiple bits of paper and notebooks scattered around, and struggling to find the information I need?

- Do I want to move away from digital planning?

- Do I find that even though there are huge choices of diaries, journals, planners and calendars on the market, none of them are ever quite right for me?

If you find you have answered yes to any of these questions, then bullet journaling may well be the new system for you.

The beauty of the system is its customizability – you can make your bullet journal any way you like it. The bullet journal – often shortened to BuJo – can be as simple or as complex as you want it to be. As you go through the book, if you see a spread that you like, you can replicate it in your own BuJo; equally, if you don't like the look of something, or you think an idea is not for you, then just ignore it.

What should my BuJo look like?

Your bullet journal can look any way you want it to look. There is no right or wrong. Whilst this level of freedom can feel a bit daunting at first, it's important to tell yourself that this is your journal, and you can do it any way you like. By all means get inspiration from this book, or from social media, but if you decide to do things completely your own way, then that's fine too.

Do you want a colorful journal? Go for it – color it in, use stickers and washi tape and colored pens to your heart's content. Or if you prefer a more simplistic, monochromatic approach then that's fine too.

Maybe you want detailed entries for every day, more akin to a traditional journal – or perhaps you just want a couple of bullet points for each day, to plan what you need to do that day. Either is fine.

What materials do I need?

The minimum you need is a notebook and pen, although you may wish to customize your BuJo through the use of color, stickers and so on.

- **Notebook** – popular notebooks include the Leuchtturm 1917, and the Moleskine. An A5 notebook with dotted paper is by far the most popular option, but squared or even lined paper, or a different sized notebook could work just as well.

- **Pen** – any pen, or indeed pencil will work for your BuJo. Some popular pens are the Staedtler fineliner pens, or Stabilo point 88 fineliner pens.

- **Decorations** – OK so you don't *need* these, but you might want them. You can of course choose to decorate your BuJo in any way at all – doodles, mandalas, stencils, stickers, washi tape, and shading are all popular ways to jazz up an otherwise monochromatic bullet journal.

GETTING STARTED

Jargon buster

The www.bulletjournal.com website makes a number of suggestions about how to begin your bullet journal, and the videos are well worth watching.

When he came up with the idea of the bullet journal, Ryder Carroll also introduced a whole lot of jargon; some new users find these words confusing and daunting, while others find them a useful way of 'learning the language of the BuJo'. Here I'll outline the jargon used by Carroll, and what it really means.

Jargon	What it actually means
Bullet journal	Notebook, planner and diary all rolled into one
Index	Table of contents that you write as you go along
Collection	Various notes / tasks all about the same topic
Future log	Calendar (typically for 6 months on a double-page spread)
Monthly log	Calendar showing all the days in a month, and the things you need to do in that month, on one double-page spread
Daily log	To do list or diary entry for a single day (typically one week to a double-page spread)
Entries	Things you write into your daily log (to do / diary entry)
Rapid logging	Writing things in short sentences or brief notes e.g. "email mum" and using symbols (see page 9)
Signifier	Stars or exclamation marks to show which tasks or notes are most important
Open tasks	Things you haven't got round to doing yet
Migration	Moving tasks from one month/week/day to another month/week/day
Module	Page about a certain topic that's not time-based e.g. books you want to read, jokes, list of addresses

As this book is aimed at beginners, I'll be using normal everyday language to explain what things are, but if you'd like to learn the jargon, go right ahead.

Key to symbols

Along with his jargon, Carroll invented a system of symbols to use as bullet points, to see at a glance what type of information the writing is about. He suggests the following:

- · Dot – used for tasks you need to do
- O Circle – used for events such as parties
- – Dash – used for random notes
- ∗ Star – used to show that something is important
- X Cross – completed task
- > Forward arrow – task you didn't complete yet, so you're moving it forwards to next month's to do list
- < Backward arrow – task you didn't complete yet, but it's not urgent, so you've delayed it for a few months (and written it in your Future Log)
- – ~~Crossed out a task~~ – task you didn't complete yet, and you've decided to abandon it

As with all things BuJo, if you don't want to use those symbols, then don't feel as though you have to (see page 121).

It's time to start!

So you've got your notebook, your pens, and the hope that this new way of planning your life will make you so much more productive. All you need to do now is put pen to paper.

It's natural to feel daunted, as you don't want to ruin your brand new notebook – what if you make a mistake? – what if something goes wrong? – what if your handwriting isn't neat? – what if your BuJo doesn't look as cute and creative as the ones in this book or on social media?

So what? This is your bullet journal, and it's important not to set your standards too high, by comparing yourself to others. Look through the pages that follow, pick one, and get started journaling. If you really feel that you can't bear to begin writing in your new journal until you're totally sure of what you're doing, then you could use some scrap paper to practice.

About the layouts in this book

The layouts in this book begin with the simplest ones, and work towards the more elaborate ones. If there is an element of a layout that you don't like, you can change it to one you do like, or one which is more suited to your needs. Pick and mix elements from different layouts to create one that is truly your own.

Remember!

The important thing with any system is that if it starts to become a chore, and yet another thing on your to do list, then you stop bothering with it. So keep it simple at first, until it becomes a habit and a pleasure. Just remember that you can chop and change: if this month, you've got time to decorate your monthly calendar with doodles and mandalas, but next month is a bit more rushed, then that's fine.

And although I have stressed the importance of experimenting, if you find a layout that really works for you and you want to reuse it – or indeed stick with it every week – then that is entirely up to you. If it works, use it.

So, you want to start a Bullet Journal?

YOU SHOULD CHECK OUT
www.bulletjournal.com
♡

Don't worry if you make a mistake!

REFLECT & Adapt

Each time you write a new weekly or monthly spread, try to improve it and if something hasn't worked, try something new.

Look online for inspiration

Make your layouts look good by doing fonts, stars, banners etc

Stationery
You can have a bullet journal in any notebook, using any pens: don't feel you have to get all the expensive gear.

Try new layouts to find what works for you.

ExPeRimEnt

WHAT ARE THE MOST **IMPORTANT** *parts of the Bujo?*

INDEX

→ AT THE FRONT OF YOUR BULLET JOURNAL, YOU WILL WRITE A LIST OF THE SECTIONS OR CONTENTS OF YOUR BUJO, AND THEIR PAGE NUMBERS

It's just a contents page which you update as you go along

COLLECTIONS

LOGS LOGS

FUTURE LOG
- Calendar
- Write out events for the next 4-6 months

MONTHLY LOG
- One-month calendar
- Write out events, appointments and tasks for the month

DAILY LOG
- A one-week spread.
- Write out events, appointments and tasks for the week

Rapid Logging

• TASK
X TASK DONE
> MIGRATED
< SCHEDULED

✳ IMPORTANT
☀ EXPLORE

CONCERNS & QUESTIONS

YOUR HAND-WRITING IS A MESS:
So what? The Bujo is about getting organized not about creating a work of art. Just go for it.

What if I forget to do it for a while?

THAT'S FINE! THE GREAT THING ABOUT BULLET JOURNALS IS THAT YOU CAN PICK UP RIGHT WHERE YOU LEFT OFF AND THERE WON'T BE LOADS OF EMPTY PAGES.

THERE'S NO TIME

KEEP IT SIMPLE
IF YOU ARE SHORT OF TIME, KEEP YOUR BUJO SIMPLE AND FUNCTIONAL: A LIST OF BULLETS, WHICH YOU TICK OFF.

SCARED OF MESSING UP?

JUST MAKE A START. IF THINGS GO WRONG, USE CORRECTION FLUID OR LEAVE IT - JUST START ALREADY!

I can't draw

DON'T BOTHER | OR | KEEP PRACTISING

FUTURE LOG

JULY

- ○ ELLIE'S BIRTHDAY - 4TH
- * ○ VACATION TO FLORIDA - 10TH - 17TH
- ○ MONICA'S BABY DUE - 19TH
- ☐ BUY GIFT FOR DAD?

AUGUST

- ○ ANNABEL'S BIRTHDAY - 18TH
- ○ DAD'S BIRTHDAY - 25TH
- ☐ BUY TENT
- ☐ BUY TABLE + CHAIRS
- △ PEDIATRICS AT YALE - 7TH

SEPTEMBER

- ☐ REFERENCING + BIBLIOGRAPHIES DUE 28TH
- △ ONCOLOGIST - 2ND
- * ○ CAMPING IN EUROPE

FUTURE LOG

OCTOBER

- ☐ EQUINE REPORT DUE 2ND
- ○ JEFFS BIRTHDAY - 9TH?
- ○ SOFIA'S PRESENTATION 27TH

NOVEMBER

- ☐ INVERTEBRATES PRESENTATION 8TH
- ○ MOM + DAD'S ANNIVERSARY - 29TH
- ☐ BUY CHRISTMAS GIFTS

> This is the Future Log layout suggested at www.bulletjournal.com. It's
> certainly easy to produce, and it will allow you to plan out future events.
> However, it's not the most decorative of layouts, and most people in
> the bullet journaling community prefer a layout which is a little more
> interesting. The following pages show some possible layouts for your
> Future Log which are more visually appealing than this one.

DECEMBER

- ○ ERICA'S BIRTHDAY - 14TH
- ☐ BREAK UP FOR CHRISTMAS - 19TH
- ☐ SEND CHRISTMAS CARDS

CALENDAR

JANUARY

M	T	W	T	F	S	S	
				1	2	3	4
5	6	7	8	9	10	11	
12	13	14	15	16	17	18	
19	20	21	22	23	24	25	
26	27	28	29	30	31		

○ 7 - DAD'S BIRTHDAY
○ 24-25 - LINCOLN PARTY
☐ 31 COMPLETE TAX RETURN
△ 15 APT AT QUEENS HOSP 9.50am
○ 1-4 END OF XMAS VACATION

FEBRUARY

M	T	W	T	F	S	S
						1
2	3	4	5	6	7	8
9	10	11	12	13	14	15
16	17	18	19	20	21	22
23	24	25	26	27	28	

○ 3 - MACMILLAN'S COFFEE MORNING
☐ FLOORBOARD ATTIC
☐ PAINT DOWNSTAIRS TOILET
○ 1-MARTHA'S BIRTHDAY (AGE 4)
○ 18 - SARAH'S BIRTHDAY
○ 27 - DAN'S BIRTHDAY
△ 23 - REVIEW AT WORK
☐ CHECK MED CERTIFICATE
○ 14-22 HALF TERM (CHARLOTTE + MAX)

MARCH

M	T	W	T	F	S	S
						1
2	3	4	5	6	7	8
9	10	11	12	13	14	15
16	17	18	19	20	21	22
23	24	25	26	27	28	29
30	31					

△ 6 - DERMATOLOGIST (SAM) 10.40am
○ POPPY'S BIRTHDAY (AGE 2) - 14th
○ DYLAN'S BIRTHDAY (AGE 15) - 28th
○ MIKE'S BIRTHDAY (AGE 50) - 30th
○ 21-22 - PARIS TRIP ⚑

FUTURE 609

January

M		5	12	19	26
T		6	13	20	27
W		7	14	21	28
T	1	8	15	22	29
F	2	9	16	23	30
S	3	10	17	24	31
S	4	11	18	25	

- ○ 7 DAD'S BIRTHDAY
- △ APT AT QUEENS HOSP 9.50
- ○ SCHOOL STARTS 5 JAN
- ○ 24-25 LINCOLN PARTY
- ☐ 31 COMPLETE TAX RETURN

February

M	2	9	16	23
T	3	10	17	24
W	4	11	18	25
T	5	12	19	26
F	6	13	20	27
S	7	14	21	28
S	1	8	15	22

- △ TEST RESULTS CONSULTATION (12)
- ○ MACMILLAN COFFEE MORN (3rd)
- ○ 1 MARTHA'S BIRTHDAY (4)
- ○ 18 SARAH'S BIRTHDAY
- ○ 27 DAN'S BIRTHDAY
- ○ 14-22 HALF TERM
- △ 23 REVIEW AT WORK
 FLOORBOARD ATTIC
 PAINT DOWNSTAIRS TOILET
 CHECK MED CERTIFICATE

March

M		2	9	16	23 30
T		3	10	17	24 31
W		4	11	18	25
T		5	12	19	26
F		6	13	20	27
S		7	14	21	28
S	1	8	15	22	29

If you find that your Future Log fills up and you're having to squeeze things in as there's not enough room on the page, then you may choose to create a Future Log which consists of four or even just three months to a double-page spread. Any fewer months than that and your Future Log is too similar to your Monthly Logs.

4 Month Plan

SEPTEMBER

1
2
3
4 O SADIE'S BABY DUE
5
6
7
8 △ OPTICIAN 4:15
9
10 🎁 MATTHEW (6)
11
12
13
14 🎁 PETE
15
16
17
18
19
20
21
22
23
24
25
26
27
28 🎁 CHRIS
29
30

OCTOBER

1
2
3 🎁 OLIVER (4)
4
5
6
7
8
9
10
11 △ HAMMERSLEY HOSP 9:15
12
13
14
15
16
17
18
19
20
21
22
23
24 🎁 SHANEEQ (16)
25
26
27
28
29
30
31

NOVEMBER

1
2
3 🎁 JORDAN (18)
4
5
6
7
8 🎁 ALEX
9
10
11
12
13
14 △ JORDAN'S RECITAL
15
16
17
18 🎁 RAPHAEL (9)
19
20
21 🎁 CARLY
22
23
24
25
26
27
28
29
30
3

DECEMBER

1
2
3
4
5
6
7
8
9
10
11
12
13
14 O MONIQUE'S BABY DUE
15
16
17
18
19
20
21 O LAST DAY OF WORK
22
23 🎁 LACHLAN
24
25 CHRISTMAS!!
26
27 🎁 TRISTAN (3)
28
29
30
31 🎁 IMOGEN (7)

NOTES

Future Log

	JANUARY	FEBRUARY	MARCH
S	1	/////	/////
M	2	/////	/////
T	3	/////	/////
W	4	1	1
T	5	2	2
F	6 🎁 PAUL	3	3
S	7	4 · SEND PHC1	4
S	8	5	5 🎁 DIANE
M	9	6	6 · APPLY FOR
T	10	7 △ YALE 9.15	7 BJC.
W	11	8	8
T	12	9	9
F	13	10 🎁 JOYCE	10
S	14	11	11
S	15	12	12
M	16	13	13
T	17 △ YALE 9.15	14	14
W	18	15	15
T	19	16	16 🎁 RHYS
F	20	17 △ DR WU 11.20	17
S	21	18	18
S	22	19	19
M	23 🎁 ANDREW	20	20
T	24	21	21 △ YALE 9.15
W	25	22	22
T	26	23	23
F	27	24	24
S	28	25	25
S	29	26	26
M	30	27	27
T	31	28 △ YALE 9.15	28
W	/////	/////	29
T	/////	/////	30
F	/////	/////	31
S	/////	/////	/////

Quarterly Plan

JAN

- Renew TV subs.
- Tax Return
- O Mum's B-Day (29th)
- O Jack's B-Day (31st)

FEB

- Car M.O.T.
- Pay off Xmas Credit Cards
- O Dylan's B-Day (13th)
- O Pippa's B-Day (17th)
- O Grandpa's B-Day (20th)

MAR

- Renew Car Insurance
- Prune Trees
- O Andy's Birthday (15th)
- O Lola's Birthday (21st)
- O Anna's Birthday (28th)
- O Lisa's Birthday (31st)

APR

- Check phone upgrade
- △ Dentist 10.40
- O Debbi's Birthday (20th)

Future Log

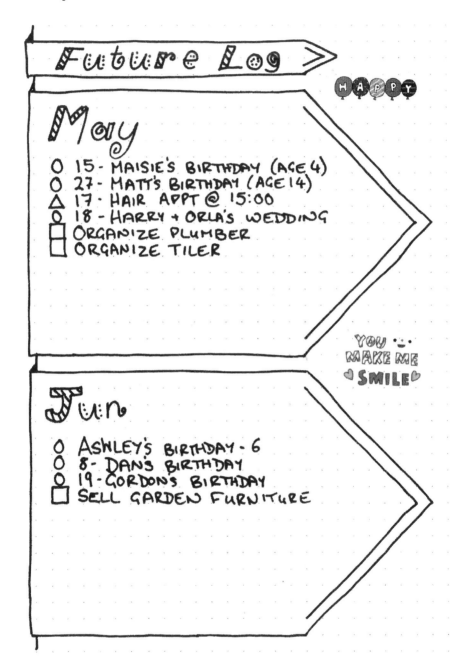

HAPPY

May

- ○ 15 - MAISIE'S BIRTHDAY (AGE 4)
- ○ 27 - MATT'S BIRTHDAY (AGE 14)
- △ 17 - HAIR APPT @ 15:00
- ○ 18 - HARRY + ORLA'S WEDDING
- ☐ ORGANIZE PLUMBER
- ☐ ORGANIZE TILER

YOU
MAKE ME
♡ SMILE ♡

Jun

- ○ ASHLEY'S BIRTHDAY - 6
- ○ 8 - DANS BIRTHDAY
- ○ 19 - GORDON'S BIRTHDAY
- ☐ SELL GARDEN FURNITURE

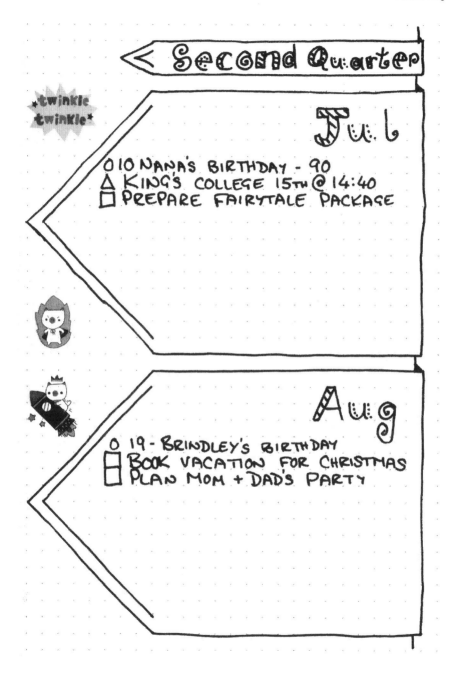

< Second Quarter

Jul

- O 10 NANA'S BIRTHDAY - 90
- △ KING'S COLLEGE 15th @ 14:40
- □ PREPARE FAIRYTALE PACKAGE

twinkle twinkle

Aug

- O 19 - BRINDLEY'S BIRTHDAY
- □ BOOK VACATION FOR CHRISTMAS
- □ PLAN MOM + DAD'S PARTY

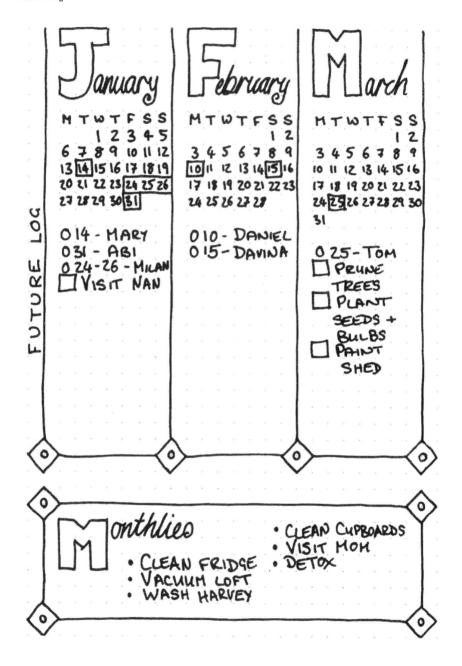

January

M T W T F S S
 1 2 3 4 5
6 7 8 9 10 11 12
13 14 15 16 17 18 19
20 21 22 23 24 25 26
27 28 29 30 31

O 14 - MARY
O 31 - ABI
O 24-26 - MILAN
☐ VISIT NAN

February

M T W T F S S
 1 2
3 4 5 6 7 8 9
10 11 12 13 14 15 16
17 18 19 20 21 22 23
24 25 26 27 28

O 10 - DANIEL
O 15 - DAVINA

March

M T W T F S S
 1 2
3 4 5 6 7 8 9
10 11 12 13 14 15 16
17 18 19 20 21 22 23
24 25 26 27 28 29 30
31

O 25 - TOM
☐ PRUNE TREES
☐ PLANT SEEDS + BULBS
☐ PAINT SHED

FUTURE LOG

Monthlies

- CLEAN FRIDGE
- VACUUM LOFT
- WASH HARVEY
- CLEAN CUPBOARDS
- VISIT MOM
- DETOX

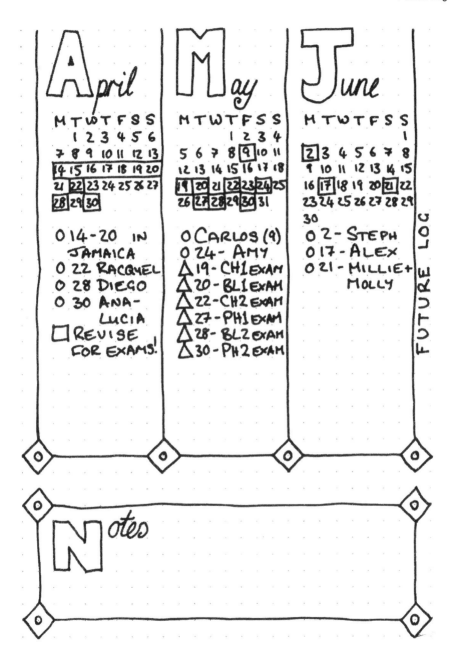

April

M T W T F S S
1 2 3 4 5 6
7 8 9 10 11 12 13
14 15 16 17 18 19 20
21 22 23 24 25 26 27
28 29 30

O 14-20 IN
JAMAICA
O 22 RACQUEL
O 28 DIEGO
O 30 ANA-
LUCIA
☐ REVISE
FOR EXAMS!

May

M T W T F S S
1 2 3 4
5 6 7 8 9 10 11
12 13 14 15 16 17 18
19 20 21 22 23 24 25
26 27 28 29 30 31

O CARLOS (9)
O 24 - AMY
△ 19 - CH1 EXAM
△ 20 - BL1 EXAM
△ 22 - CH2 EXAM
△ 27 - PH1 EXAM
△ 28 - BL2 EXAM
△ 30 - PH2 EXAM

June

M T W T F S S
1
2 3 4 5 6 7 8
9 10 11 12 13 14 15
16 17 18 19 20 21 22
23 24 25 26 27 28 29
30

O 2 - STEPH
O 17 - ALEX
O 21 - MILLIE +
MOLLY

FUTURE LOG

Notes

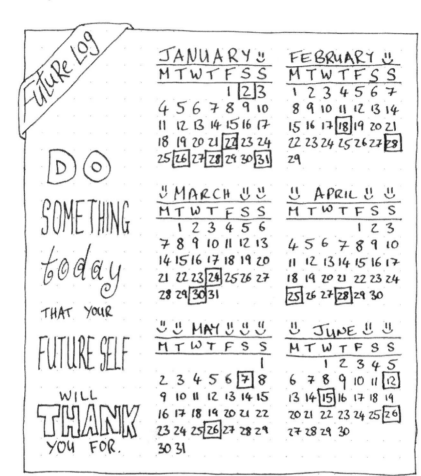

Future Log

DO SOMETHING today THAT YOUR FUTURE SELF WILL THANK YOU FOR.

JANUARY ☺

M	T	W	T	F	S	S
				1	2	3
4	5	6	7	8	9	10
11	12	13	14	15	16	17
18	19	20	21	22	23	24
25	26	27	28	29	30	31

FEBRUARY ☺

M	T	W	T	F	S	S
1	2	3	4	5	6	7
8	9	10	11	12	13	14
15	16	17	18	19	20	21
22	23	24	25	26	27	28
29						

☺ MARCH ☺ ☺

M	T	W	T	F	S	S
	1	2	3	4	5	6
7	8	9	10	11	12	13
14	15	16	17	18	19	20
21	22	23	24	25	26	27
28	29	30	31			

☺ APRIL ☺ ☺

M	T	W	T	F	S	S	
					1	2	3
4	5	6	7	8	9	10	
11	12	13	14	15	16	17	
18	19	20	21	22	23	24	
25	26	27	28	29	30		

☺ ☺ MAY ☺ ☺ ☺

M	T	W	T	F	S	S
						1
2	3	4	5	6	7	8
9	10	11	12	13	14	15
16	17	18	19	20	21	22
23	24	25	26	27	28	29
30	31					

☺ JUNE ☺ ☺

M	T	W	T	F	S	S
		1	2	3	4	5
6	7	8	9	10	11	12
13	14	15	16	17	18	19
20	21	22	23	24	25	26
27	28	29	30			

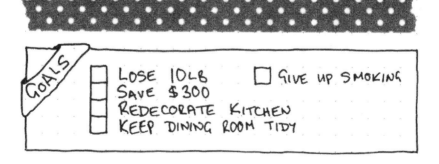

GOALS

- [] LOSE 10LB
- [] SAVE $300
- [] REDECORATE KITCHEN
- [] KEEP DINING ROOM TIDY
- [] GIVE UP SMOKING

Stuff

O 2 OLIVER'S B·DAY
O 22 ELEANOR'S B·DAY
O 26 DAPHNE'S B·DAY
O 28 AVA'S B·DAY
O 31 PAT + OSCAR'S ANNIVERSARY
☐ ORDER BROWN BIN

JAN

O 18 ANDREW'S BIRTHDAY
O 28 JACKIE'S BIRTHDAY
☐ PREPARE ANNUAL REVIEW

FEB

O 24 SAM'S BIRTHDAY
☐ ORDER BLUE BIN
△ 30 ONCOLOGIST 9·45am

MAR

O 25 DAD'S BIRTHDAY
O 28 GRANDMA'S BIRTHDAY

APR

O 7 MEEMAW'S BIRTHDAY
O 26 ROCCO'S BIRTHDAY

MAY

O 12 AMBER'S BIRTHDAY
O 15 EDDIE'S BIRTHDAY
O 26 MY BIRTHDAY

JUN

APRIL - MONTHLY LOG

1 W
2 T
3 F
4 S
5 S
6 M
7 T O SCARLETT'S BIRTHDAY (AGE 2)
8 W
9 T
10 F
11 S · NO FOOTBALL
12 S
13 M
14 T O LEVI'S BIRTHDAY (AGE 17)
15 W
16 T
17 F ⊙ MARY COMING FOR DINNER
18 S
19 S ⎫
20 M ⎪
21 T ⎬ TENERIFE
22 W ⎪
23 T ⎪
24 F ⎪
25 S ⎭
26 S
27 M
28 T △ ONCOLOGIST 11.30
29 W
30 T

APRIL - MONTHLY LOG

- BUY NEW CHAIRS
- PAINT BEDROOM
- VISIT ALICE
- WRITE INTRODUCTION
- REVISE FOR HB1
- REVISE FOR HB2
- ORGANIZE BOOKSHELF
- BUY CLOTHES FOR VACATION

This is the Monthly Log layout suggested on the bullet journal official website. As with the other designs suggested by Ryder Carroll, it is functional and utilitarian, but not really a crowd-pleaser. However, if you are new to bullet journaling, a design like this gives you a good starting point to embellish. The alternative designs that follow provide different ways to lay out your Monthly Logs in ways which you will hopefully find just as functional, but a little more pleasing to the eye.

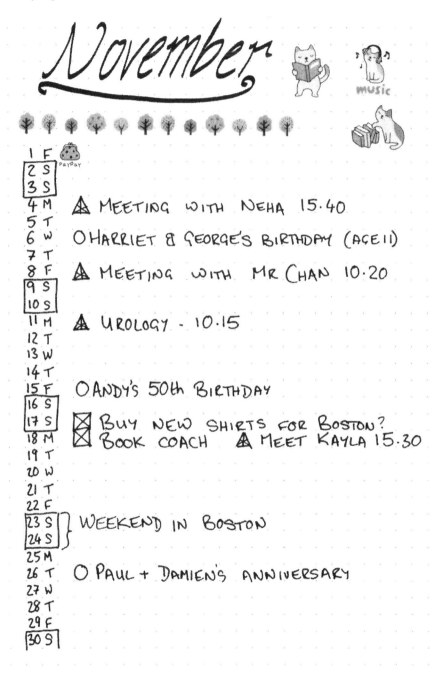

November

1 F — PayDay

2 S

3 S

4 M — △ MEETING WITH NEHA 15.40

5 T

6 W — O HARRIET & GEORGE'S BIRTHDAY (AGE 11)

7 T

8 F — △ MEETING WITH MR CHAN 10.20

9 S

10 S

11 M — △ UROLOGY - 10.15

12 T

13 W

14 T

15 F — O ANDY'S 50th BIRTHDAY

16 S

17 S — ☒ BUY NEW SHIRTS FOR BOSTON?
 ☒ BOOK COACH △ MEET KAYLA 15.30

18 M

19 T

20 W

21 T

22 F

23 S — } WEEKEND IN BOSTON

24 S

25 M

26 T — O PAUL + DAMIEN'S ANNIVERSARY

27 W

28 T

29 F

30 S

We searched through the door & beyond

TO DO LIST!

- ☒ Buy new shirts for Boston
- ☒ Buy card for Paul + Damien
- ☒ Visit Grandma
- ☐ Start Munro project
- ☐ Print pass for Rachel

This is a very simple layout which appears much more complex than it is, thanks to a few stickers and some washi tape.

Below is an activity tracker, which is an easy way to keep track of regular goals.

MONTHLY MAZE

Tracker

	1	2	3	4	5	6	7	8	9	10
DRIVING	X	X	X		X	X	X		X	
REVISION	X	X		X	X			X	X	X
HEALTHY FOOD		X	X		X		X	X	X	

	11	12	13	14	15	16	17	18	19	20
DRIVING		X	X		X		X		X	
REVISION	X									
HEALTHY FOOD		X		X		X	X	X		X

	21	22	23	24	25	26	27	28	29	30
DRIVING					X	X	X	X		X
REVISION	X									
HEALTHY FOOD	X	X			X	X	X			

This is a simple variation on the easiest monthly layout. You could designate each side for something in particular, such as home and work, or important and less important tasks.

The geometric pattern was drawn with a Spirograph - a tool which can create circular and other patterns.

FEB

🎁 POPPA'S BIRTHDAY ——

11:00-12 FEEDING CLINIC —

🎁 SAMINA ———————

• UPLOAD BABY PICS ——
 (DEADLINE)

🎁 JAYDEN (5) ————

15:00 HEALTH VISITOR —

1 T - CAESARIAN BOOKED!!!
2 F
3 S
4 S
5 M - 10:30 MIDWIFE
6 T 13:00-15:00 BREASTFEEDING
7 W
8 T
9 F - 0 VALERIE'S ICE SKATING
10 S
11 S
12 M - 13:00-15:00 BREASTFEEDING
13 T
14 W
15 T
16 F - 11:00 HEALTH VISITOR
17 S
18 S
19 M - 13:00-15:00 BREASTFEEDING
20 T
21 W
22 T - DINNER WITH KATE
23 F
24 S
25 S
26 M - 13:00-15:00 BREASTFEEDING
27 T
28 W

MARCH

1	F
2	S
3	S
4	M
5	T
6	W
7	T △10:00 MR SANTIAGO
8	F
9	S
10	S
11	M
12	T
13	W △11:00 MR BARON-
14	T LEAVERS
15	F
16	S O PAIGE - GRADE 4 FLUTE
17	S
18	M
19	T
20	W
21	T
22	F
23	S O SIX FLAGS
24	S
25	M △9:00 MISS ABBOTT
26	T
27	W
28	T
29	F
30	S O HARLEY'S PARTY
31	S

TASKS

- PLANT SEEDLINGS
- BUY NEW PHONE
- RE-DO BOOKSHELF

A different way to keep track of your monthly activities is to use tally marks - one mark for each day you did the activity. This takes up less space too.

HEALTH

LHT LHT LHT IIII
EXERCISE

LHT LHT III
WATER (8 GLASSES)

LHT LHT I
HEALTHY FOOD

LHT LHT LHT LHT LHT I
NO SMOKING

BIRTHDAYS

2ND AUNT MAGGIE
9TH POLLY
13TH SIMON
27TH CANDICE
29TH CHUCK

JANUARY

	MON	TUE	WED	THU	FRI	SAT	SUN

MON
- 5
- 12 △ OPTICIAN 14:20
- 19 O RIANE'S BIRTHDAY
- 26

TUE
- 6 O JAYNE'S BIRTHDAY
- 13
- 20
- 27

WED
- 7
- 14
- 21 O PHIL'S BIRTHDAY
- 28

THU
- 1
- 8
- 15 △ LUNCH WITH SANDY
- 22
- 29

FRI
- 2 ☐ BROUGH PRESENTATION
- 9 ☐ TWIGG PRESENTATION
- 16 ☐ GREEN PRESENTATION
- 23 ☐ FOOTE PRESENTATION
- 30 ☐ DIXON PRESENTATION

SAT
- 3
- 10 O JOEL'S DINNER PARTY
- 17
- 24 O SWIMMING GALA 4pm
- 31 $ PAY DAY!!

SUN
- 4 O JACK'S KARATE GRADING
- 11
- 18
- 25

TO DO

- [] CHECK DATES FOR PHOTO SHOOT
- [] BUY PRESENT FOR DAD
- [] GET QUOTES FOR BATHROOM
- [] RENEW HOME INSURANCE
- [] BOOK SCAN AT KING'S
- [] SET UP A NEW BLOG
- [] USE UP AMAZON VOUCHERS

HAPPINESS

IS FOUND WHEN YOU

STOP COMPARING

YOURSELF TO

OTHERS

An alternative way to present your Monthly Log is on a calendar such as this. It is a matter of personal preference whether you choose to list the days down the side or along the top. As with all things BuJo, just experiment and find which you prefer, or mix it up each month.

This spread is also more spacious than some of the list-like Monthly Logs: this can do wonders for your stress levels if you find yourself looking at a busy month and worrying about how you're going to manage it all.

MAY

MON	TUE	WED	THU
✳	1 ✗CALEB-GYM	2	3 ✗MAYA- SWIMMING
7	8 ✗CALEB-GYM	9	10 ~~MAYA SWIMMING~~
14 ⚠ MEETING RE: MERGER 9.00	15 ✗CALEB-GYM	16	17 ✗MAMA- SWIMMING ○ SAM. BIRTHDAY
21	22 ~~CALEB-GYM~~	23	24 ✗MAYA- SWIMMING
28	29 ✗CALEB-GYM	30	31 ~~MAYA SWIMMING~~

NOTES

- CARLA AND MIKE GETTING DIVORCED
- BATHROOM TAP IS LEAKING
- JACOB CUT HIS FIRST TOOTH

MONTHLY LOG

FRI	SAT	SUN
4 △ BRIONY· SPEECH THERAPY 14·20	5	6
11	12 O DANA's BIRTHDAY	13 O VISIT GRAMPS
18 △ OPTICIAN· 10·40	19	20
25 £ PAYDAY	26	27 O PAULETTE's BIRTHDAY
✳	✳	✳

TO DO

- ▷ BUY NEW DINING TABLE
- ✗ CANCEL MAIL ORDER
- ▷ CHECK BOOK ON AMAZON
- ◁ REPLACE FENCE?

GRATITUDES

6/5 • TAKING JACOB TO MUM + BABY GROUP	13/5 • GRAMPS STILL GOING STRONG AT 97
20/5 • PIZZA! • SNUGGLES WITH MAYA	27/5 • I HAVE SUCH GREAT FRIENDS.

AUGUST

	home 👫	work 👓
1 M		
2 T		
3 W		△ 9:00 BRIEFING
4 T	O MUSIC FESTIVAL 10·17:00	
5 F		
6 S	O OLIVIA'S BIRTHDAY	
7 S		
8 M		△ CONFERENCE IN
9 T		GEORGETOWN
10 W		
11 T		
12 F		
13 S		
14 S	△ ICE SKATING 10AM	
15 M		
16 T		
17 W	O LEROY'S BIRTHDAY	△ 9:00 BRIEFING
18 T		
19 F	O AUNT MAY'S BIRTHDAY	
20 S		
21 S		
22 M	△ MEETING WITH PAYROLL →	11:00
23 T		
24 W		
25 T	△ LUNCH WITH CHARLEY	
26 F		
27 S		
28 S		
29 M		
30 T	O KADYLEIGH'S BIRTHDAY	
31 W		

it's summer

DOGS 🐕

- MARLEY READY TO HOME

→ PICK UP DILLY

→ PICK UP MZ183
→ SHAMPOO + CLIP MZ183 (MIZZY)

→ PICK UP J21-8 (ALFIE, DIXIE, POM, MISTY, DINGO, TAMMY, MAX)

- MIZZY READY TO HOME

- DILLY READY TO HOME

- ALFIE, MISTY, DINGO READY TO HOME

Tracker

	Dust	Vacuum	Kitchen	Bathroom	Hard Floors	Laundry	Ironing	Dishwasher	Fridge	Bedrooms
1-7 Aug		X	X	X	X	X	X	X	X	X
8-14 Aug		X	X	X	X	X	X	X	X	X
15-21 Aug	X	X	X	X	X	X	X	X	X	X
22-28 Aug	X	X	X	X	X	X	X	X	X	X

BACK to school

- [x] SHIRTS — £9
- [x] TROUSERS — £12
- [x] SHORTS — £6
- [] SOCKS
- [] SHOES
- [x] BLAZER — £32
- [x] BAG — £15
- [] PE TSHIRTS
- [] PE SHORTS
- [x] FOOTBALL BOOTS — £24
- [x] ~~LUNCH BAG~~
- [x] SCARF — £4
- [] COAT
- [x] FOLDERS — £5
- [x] PLASTIC POCKETS — £1
- [x] PENS — £1
- [x] PENCIL CASE — £3
- [x] HIGHLIGHTERS — £2
- [x] GLUE STICK — £2

JUNE

Monday	Tuesday	Wednesday	Thursday	Friday
////	////	1	2 ○ EDDIE'S BIRTHDAY	3
6	7	8	9 ▲ MEET PATRICK 1·30	10
13 ○ SAM'S BIRTHDAY	14 ▲ MEET TINA 1.30	15 ○ TRIP TO CASTLEFORD	16	17 ○ DATE NIGHT
20	21	22	23 ▲ MEET PATRICK 1.30	24
27	28 ○ BOSTON ▲ MEET TINA 1.30	29	30 $ PAYDAY	

TO DO

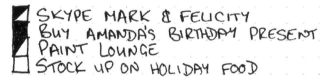

- SKYPE MARK & FELICITY
- BUY AMANDA'S BIRTHDAY PRESENT
- PAINT LOUNGE
- STOCK UP ON HOLIDAY FOOD

saturday sunday

saturday	sunday
4	5 O.T.R.D.
11 ○ Pippa's Birthday	12 O.T.R.D.
18	19 O.T.R.D.
25 ○ Golf Tournament	26 O.T.R.D.

I AM WITH YOU AND WILL WATCH OVER YOU WHERE EVER YOU GO.

GENESIS 28:15

"SPENDING LOG"

Day	FOOD	EAT OUT	CLOTHES	MAKE UP	BEAUTY	NIGHT OUT	BOOKS	CIGS	MISC	TOTAL
1								■		$6
2	■									$25
3	■		■		■		■			$70
4					■					$30
5							■	■		$80
6	■					■		■		$100
7				■						$18
8	■							■		$32
9										—
10	■			■			■			$95
11	■	■		■			■			$140
12							■			$10
13		■								$9
14									■	$11
15				■	■					$45
16		■					■			$19
17							■			$6
18	■	■						■		$150
19	■		■							$60
20										—
21										$6
22		■						■		$35
23	■									$45
24			■							$30
25			■	■			■			$65
26	■						■			$40
27						■				$8
28										$6
29	■							■		$55
30							■			$15

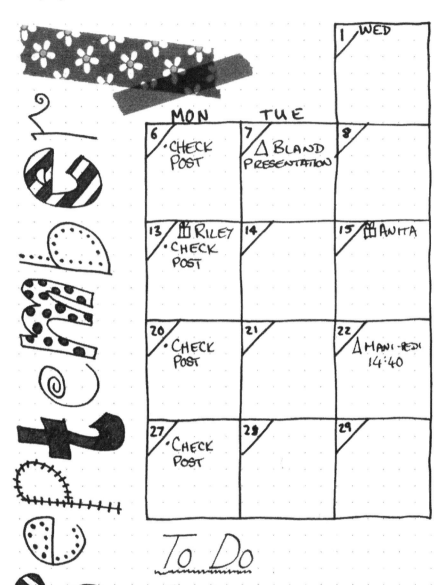

September

MON	TUE	WED
		1 WED
6 · CHECK POST	7 △ BLAND PRESENTATION	8
13 🎁 RILEY · CHECK POST	14	15 🎁 ANITA
20 · CHECK POST	21	22 △ MANI-PEDI 14:40
27 · CHECK POST	28	29

To Do

- FIND PLUMBER FOR BATHROOM
- GET RID OF WATER TANK
- PRUNE TREES FOR FALL

2 THU	3 FRI	4 SAT	5 SUN
		· Dust · Bathroom	
9	10 △ Hair 9.30 · Dust · Bathroom	11 🎁 Parker WEEKEND IN CASTLEFORD →	12
16 △ Mr Bosworth 15:20	17 · Table · Dust · Bathroom	18 WEEKEND IN ← SPRINGFIELD →	19
23 ← TRIP TO WASHINGTON →	24	25 · Dust · Bathroom	26
30 🎁 Brad			

MEMORIES

* SEP 9 - PLAYING BALL WITH
 PARKER + CARSON IN THE PARK
 IN THE RAIN!
* SEP 18 - BEAUTIFUL VIEWS OVER
 SPRINGFIELD ON A WARM
 DAY

43

TWO WEE

November

1 WED	2 THU	3 FRI
☑ EMAIL JANICE ☑ EMAIL HEAD OFFICE ☑ SKYPE ROGER	☑ CHECK MATERIALS FOR 162 4th STREET ☑ SURVEY AT 194A SPRINGDALE	☑ COMPLETE ST. ☑ CHECK FOR GEORGE
6 MON	7 TUE	8 WED
☑ COMPLETE 207 GEORGE ST.	☑ CHECK MATERIALS FOR 194A SPRING-DALE ☑ SURVEY AT MARSDEN SCHOOL	☑ EMAIL ☑ 162 ☑ 207 ☑ 1462
11 SAT	12 SUN	13 MON

If you are finding that there isn't enough space to write all your appointments on a Monthly Log, you could try a Two-weekly Log. A spread like this gives plenty of space for each day, without any clutter. If you prefer your weekends to be at the end of the row rather than 'moving around' then just produce a design with seven columns. If the Two-weekly Log works for you, you might even choose to do away with your Daily Log.

KLY PLAN

162 4th MATERIALS 207 ST	**4 SAT** ☑ Buy MOP ☑ Buy CLEANING FLUID ☒ MOP CONSERV. FLOOR	**5 SUN** ☑ MOP CONSERVAT. FLOOR
RECEIPTS: 4th St GEORGE SALEM	**9 THU** ☑ ORDER MATERIALS FOR MARSDEN SCHOOL ☑ COMPLETE 194A SPRINGDALE	**10 FRI** O PENNY'S BIRTHDAY ☑ QUOTE FOR MARSDEN SCH. ☑ CHECK MATERIALS FOR MARSDEN
MARSDEN	**14 TUE** ☑ MARSDEN SCH. ☑ SURVEY AT 182 LINCOLN ROAD	**15 WED** ☑ EMAIL RECEIPTS: ☑ 194A SPRINGDALE ☑ MARSDEN SCH.

1. T
2. F
3. S ○ ELLIE'S BIRTHDAY
4. S
5. M ☐ BLOG POST
6. T ○ JAKE - WAR AND PEACE 18:30
7. W
8. T ○ AUTUMN'S BIRTHDAY
9. F
10. S
11. S ☐ SKYPE SHANEA
12. M ○ SHANEA'S BIRTHDAY
 ☐ BLOG POST
13. T
14. W
15. T ○ J.C. SUPERSTAR 19:30
16. F

FEBRUARY - MARCH

| 20 | MONDAY | 27 | MONDAY |
| | | | |

| 21
 O ANITA'S HEN DO?
 ~ WORK | TUESDAY | 28 | TUESDAY |

| 22
 △ MRS FRENCH 8·00
 △ MISS DERBY 9·50
 △ MRS BLEAK 15·20
 △ MISS O'DONNELL 16·00 | WEDNESDAY | 1
 △ MS VANESSA 10·14
 △ MISS BARKER 12·00
 △ MISS DEAN 14·50
 2 △ MRS WONG 17·00 | WEDNESDAY |

| 23
 △ MISS FLAHERTY 8·50 | THURSDAY | 2 | THURSDAY |

| 24
 △ MRS CASSIDY 9·40
 △ MISS CARR 11·20
 △ MR BROOKES 14·00 | FRIDAY | 3
 △ MISS TAILOR 13·20 | FRIDAY |

| 25
 △ MISS PARKES 10·00 | SATURDAY | 4 | SATURDAY |

| 26 | SUNDAY | 5
 O BETH'S BIRTHDAY | SUNDAY |

AUG 5 - WED

- PHONE DR NOVAK
- PHONE PLUMBER
- BLOG POST

O JANET & KELVIN'S ANNIVERSARY

- FOOD SHOP

AUG 6 - THU
- PHONE ROGER

△ MEETING WITH HR @ 10.00

* · CHECK PASSPORT

AUG 7 - FRI

- PHONE PHARMACY
- PICK UP TABLETS
- CHECK LAPTOP IS CHARGED

* · CHECK TICKETS

△ MEETING WITH MANDY

AUG 8 - SAT
* · PACK SUITCASE
- BOOK TAXI
- TURN OFF GAS
- PUT LIGHTS ON TIMERS
- LOCK CAT FLAP
- TAKE SNOWBALL TO DIANE'S
- WITHDRAW CASH
- PRINT BOARDING PASS
- CHECK HAND LUGGAGE

This Daily Log suggested by Ryder Carroll is just as sparse as his Future Log and Monthly Log.

Many of the Daily Logs which feature in this book, as well as those which are shared online, show an entire week on one page, or across a double-page spread: for that reason, a Weekly Log seems a more apt name. Whatever you wish to call them, Weekly Logs / Daily Logs are the backbone of the bullet journal; without them, the BuJo is little more than a calendar.

DECEMBER 15-21

MON 15
- BUY FLAG
- BUY CHEESE
- BUY STENCIL

TUE 16
- PHONE AMANDA
- RENEW TAX
- CAR - SERVICE 10am
- SCHOOL PICK UP 3·45
- BUY CARD FOR SOPHIE

WED 17
- ○ SOPHIE'S BIRTHDAY
- BUY CARD!!!!!

THU 18
- MAKE DINNER
- DO WHITE LAUNDRY
- GET MAP OF JAPAN →PRINT + LAMINATE

FRI 19
- CHECK FIRE

SAT 20
- GO TO FLOWER SHOW WITH S.

BRAIN DUMP
- BUY R.C. CAR
- XMAS WRAPPING PAPER

SUN 21
- GERMAN MARKET

Monday MAR [17]

- ⊠ PHONE JASMINE
- ~~GYM~~
- ■ TAKE MAX TO TENNIS
- ! ▲ MEETING WITH H.R. 9.00

WATER

MOOD

[18] Tuesday MAR

WATER

MOOD

- ■ PHONE JASMINE
- ■ SASHA - PRESENT
- ▲ MEETING @ LUNCH IN B107
- ▲ MEETING @ 3.30 IN B219
- ■ DO LAUNDRY

Wednesday MAR [19]

- ⊠ FOLD + PUT AWAY LAUNDRY
- ● DATE NIGHT
- ■ PHONE MUM RE: BIRTHDAY
- ⊠ GIVE PRESENT TO SASHA
- ◢ STELLA - EMAIL
- ! ▲ MIDWIFE @ 2.15
- ! ● C.R.T. EXAM

WATER

MOOD

[20] Thursday MAR

WATER

MOOD

- ☐ PHONE MARTIN @ 10.00am
- ○ SASHA'S BIRTHDAY
- ☐ SUPERMARKET SHOPPING
- ☐ FOLD + PUT AWAY LAUNDRY
- ☐ GIVE PRESENT TO ~~SASHA~~
- ☐ EMAIL STELLA

January 3-8

Mon 3rd
△ 9:40 Mr Ali
· Buy Cheese

Tue 4th
· Buy Shower Gel
· Pick up Aurora 3:40

Wed 5th
△ 10:15 Hannah Sald
△ 11:30 Kate Prichard
△ 13:15 Brigitte S.

Thu 6th
· Phone Mom
· Check Barney's Forms
· Feed Monty

Fri 7th
△ 10:00 Anneka Jay
△ 11:15 N.I.S.T. video Conference
· Check N.I.S.T. notes

Sat 8th
△ Meet Carlie for Lunch

To Do
· Dry clean black dress
· Book hair appt
· Phone Rachel - surprise party
· Prepare Nan's hamper
· Get ideas for Imogen's party costume

"Although no one can go back and make a new start, anyone can start from now and make a new ending. Carl Bard"

Monday 7th

☐ PHONE IMRAN
CHECK DATES FOR
PHOTO SHOOT

- ☑ MINDFULNESS
- ☑ 8 GLASSES OF WATER
- ☐ EXERCISE
- ☑ HEALTHY FOOD

Tuesday 8th

△ DENTIST 9.50

- ☑ MINDFULNESS
- 7 8 GLASSES OF WATER
- ☑ EXERCISE
- ☑ HEALTHY FOOD

Wednesday 9th

☐ EMAIL K.R.T.
☐ CHECK FLIGHT
TIMES - RIO

- ☐ MINDFULNESS
- 6 8 GLASSES OF WATER
- ☑ EXERCISE
- ☑ HEALTHY FOOD

Thursday 10th

☐ PHONE PLUMBERS
☐ NEW RECIPE?

- ☑ MINDFULNESS
- ☑ 8 GLASSES OF WATER
- ☐ EXERCISE
- ☐ HEALTHY FOOD

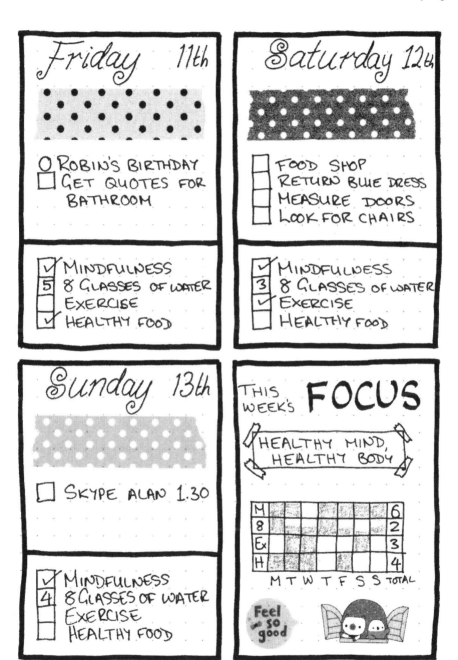

Friday 11th

O ROBIN'S BIRTHDAY
☐ GET QUOTES FOR BATHROOM

☑ MINDFULNESS
5 8 GLASSES OF WATER
☐ EXERCISE
☑ HEALTHY FOOD

Saturday 12th

☐ FOOD SHOP
☐ RETURN BLUE DRESS
☐ MEASURE DOORS
☐ LOOK FOR CHAIRS

☑ MINDFULNESS
3 8 GLASSES OF WATER
☑ EXERCISE
☐ HEALTHY FOOD

Sunday 13th

☐ SKYPE ALAN 1.30

☑ MINDFULNESS
4 8 GLASSES OF WATER
☐ EXERCISE
☐ HEALTHY FOOD

THIS WEEK'S **FOCUS**

HEALTHY MIND, HEALTHY BODY

	M	T	W	T	F	S	S	TOTAL
M								6
8								2
Ex								3
H								4

Feel so good

Mon 28

🎁 MARSHA
- PHONE SIMON BURKE - CANTOWN PROJECT
- RETURN GREEN DINOSAUR

Tue 29

- SKYPE MATTHEW SYMONS
- CANTALOUPE PAINT

Wed 30

🎁 ADAM
- BLOG POST - GOLDEN FURNITURE
- $ BUY HIGHLIGHTERS
- $ CINEMA WITH ADELE

Thu 1

- PICK UP TABLETS
- $ PHONE CHARGER (CAR)

Fri 2

- △ DR WRIGHT 11.15
- △ PHONE APPT - ROBERT DONCASTER 13.00
- $ LUGGAGE TAGS

Sat 3

- PACK CASE
- PASSPORT CHECK
- $ CURRENCY
- $ CAR PARKING

- $ AIRPORT BRUNCH?
- $ BOOK?

🕐 FLIGHT 14:30

SUN 4

✂ FLY TO LIMA!!!

ARRIVE 12·07

TASKS

- PACK FOR LIMA
- TURN OFF GAS
- CLOSE WINDOWS
- LOCK DOORS
- SET LIGHT TIMERS
- SHUT BLINDS
- CANCEL NEWS PAPERS

COLLECT
MOMENTS
NOT
THINGS

CALENDAR

JUNE

M	T	W	T	F	S	S	
		1	2	3	4	5	6
7	8	9	10	11	12	13	
14	15	16	17	18	19	20	
21	22	23	24	25	26	27	
28	29	30					

JULY 1 2 3 4
5 6 7 8 9 10 11

	SHOWER	MAKE-UP	WATER x8	EXERCISE	PRAY	STUDY	INSTAG.	PINTEREST	F-BOOK	TWITTER
Mo	X	X	X	X	X	X	X	X	X	X
Tu	X	X		X	X	X	X		X	X
We	X	X	X	X	X		X	X	X	X
Th	X	X	X		X	X	X	X	X	X
Fr	X	X		X		X	X	X	X	X
Sa	X		X	X	X	X		X	X	X
Su	X		X		X	X	X	X		X

September
19-25

	WORK	HOME
MON	O SONJA'S DUE DATE △ HR MEETING 9.30	O JACKSON- SWIMMING
TUE		$ BUY WRAPPING PAPER
WED	△ LEVEL 1 MEETING 9.30 · EMAIL APP. FORM TO 50(?) APPLICANTS △ LEVEL 2 MEETING 1.30	
THU	△ LEVEL 3 MEETING 10.30	O DATE NIGHT
FRI	· INTERVIEWS BEGIN 9.00 △ 4.30 FEEDBACK TO H.O.	
WEEKEND	· PREPARE INTRO TASKS	O SAT - ALISSA'S PARTY 16:30 O SAT - SWIMMING GALA 10.00 O SUN - SASKIA'S BABY SHOWER

To Do

- FOOD SHOP
- LAUNDRY x3
- PRACTISE FLUTE
- VISIT ALEX
- $ BUY
 - NOTELETS
 - PHOTO FRAME
 - SOCKS
 - COTTON BUDS
 - SHOWER GEL

Meals

M - SOUP
 - CHICKEN + VEG
T - SALAD
 - GAMMON + FRIES
W - CHEESE SANDWICH
 - SPAGHETTI BOL
T - SOUP
 - PIZZA
F - SAUSAGE ROLL
 - TAKE OUT
S - VEG WRAPS
 - STIR FRY
S - FISH PIE
 - SUNDAY ROAST

Notes

- SONJA'S BABY IS 1 WEEK OVERDUE

Enjoy the little things. One day you'll look back and realize they were the big things. KURT VONNEGUT

57

SEPTEMBER → OCT

MON 28
- ▲ MEETING WITH TINA 09:45
- ▲ MEETING WITH M. STAFFORD 15:20
- ▲ MEETING WITH R. CREED 16.15

TUE 29
- ▲ MEETING WITH K. HARTLEY 10:40
- ▲ MEETING WITH CRAIG 11.40
- ▲ MEETING WITH K BRAMLEY 13:20
- △ LUNCH WITH SALLY 12:00

WED 30
- ▧ PHONE J THOMPSON 07950 861349 (MESSAGE LEFT)
- ▲ MEETING WITH J BROADHURST 14.20

THU 1
- ▧ PHONE K BROOKS 07971 342839
- ▧ PHONE P HOPE 07949 841206
- ▧ PHONE CRAIG
- ▧ PHONE R BLACK re: AJK1.1
- ▧ MEETING WITH P. GREEN 14:20
- ▧ PHONE D. PATEL 07847 363642

FRI 2
- ▲ MEETING WITH NICK 16:20
- ▧ CHECK MAILSHOT 149
- ☐ SEND MAILSHOT 149

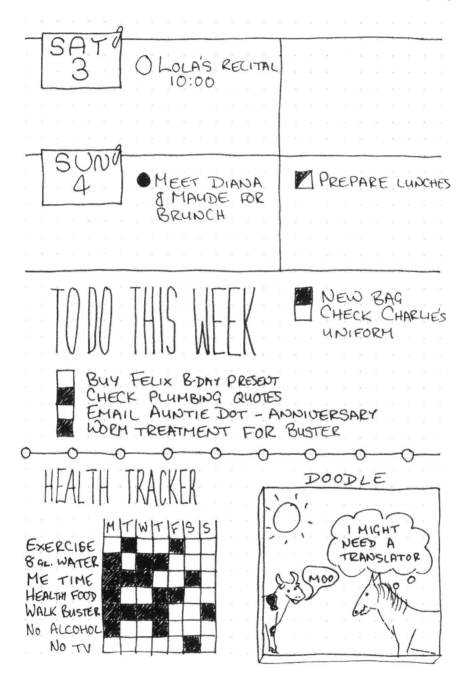

SAT 3
○ LOLA'S RECITAL 10:00

SUN 4
● MEET DIANA & MAUDE FOR BRUNCH

☑ PREPARE LUNCHES

TO DO THIS WEEK

◨ NEW BAG
☐ CHECK CHARLIE'S UNIFORM

☐ BUY FELIX B-DAY PRESENT
◨ CHECK PLUMBING QUOTES
◨ EMAIL AUNTIE DOT - ANNIVERSARY
◧ WORM TREATMENT FOR BUSTER

HEALTH TRACKER

	M	T	W	T	F	S	S
EXERCISE							
8 GL. WATER							
ME TIME							
HEALTH FOOD							
WALK BUSTER							
NO ALCOHOL							
NO TV							

DOODLE

I MIGHT NEED A TRANSLATOR

MOO

October October October

Monday
17

🎁 DON

- PHONE PAM
- PHONE TREE SURGEON
- PHONE WASTE REMOVAL

Tuesday
18

🎁 HANNAH

- SKYPE MO
- SKYPE ANN-MARIE
- PHONE ABI (TASKER'S)

Wednesday
19

- TAKE SHIRTS BACK
- CHECK PAY

Tasks

- TAKE OUT OLD BATHROOM
- REPAINT SKIRTING BOARDS

Moods

M	😊 NO WORK
T	😊 WORK
W	😷 SICK
T	😊 ALL GOOD
F	😟 FAMILY
S	😣 FAMILY
S	😊 FRIENDS

Time tracker

| WORK | ⊞⊞ ⊞⊞ ⊞⊞ ⊞⊞ ⊞⊞ ⊞⊞ ||| |
|---|---|
| SLEEP | ⊞⊞ ⊞⊞ ⊞⊞ ⊞⊞ ⊞⊞ ⊞⊞ ⊞⊞ ⊞⊞ |
| FAMILY | ⊞⊞ ⊞⊞ ⊞⊞ ⊞⊞ ⊞⊞ || |
| FRIENDS | ⊞⊞ ⊞⊞ |
| ONLINE | ⊞⊞ ⊞⊞ ⊞⊞ ⊞⊞ ⊞⊞ ⊞⊞ | |
| OUTDOORS | ⊞⊞ | |

Thursday
20

Friday
21

- Buy new ink (color)
- Buy sticky notes
- Write Pete a reference

Saturday
22

- Check Adele's form

Sunday
23

🎁 Cath

Notes

- I think my sickness on Wed was due to the sticky buffalo wings at Bernie's. ~ Order the burger next time!

- Huge spider in the bath !!

Weather

M	☀️	19°
T	☀️	20°
W	☀️	17°
T	☀️	22°
F	🌧️	19°
S	🌧️	18°
S	☀️	21°

MON

7

■ SANDRA-
 MEET-UP
■ MAXINE-
 PRESENT

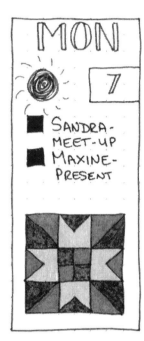

TUE

8

△ DRS 11.20
 LOOK AFTER
 MILLIE &
 BEA
▷ INSTAGRAM

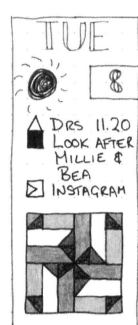

WED

9

○ MAXINE'S
 BIRTHDAY
◪ MAKE
 CURTAINS
▷ INSTAGRAM
□ CHECK HOME
 INSURANCE
▷ FOOD SHOP

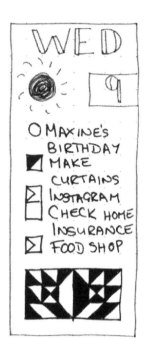

THUR

10

▲ PAYROLL @ 2.40pm
 MEETING WITH
 KATE & ANTHEA 3pm
■ FOOD SHOP

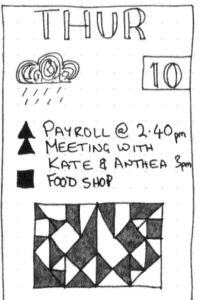

FRI

11

○ PAUL'S PARTY
◪ BUY WINE + FLOWERS

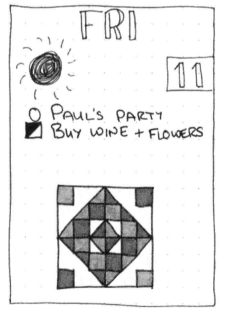

SAT `12`

○ ANN-MARIE'S BABY DUE
■ INSTAGRAM
□ BUY BAG
○ BADMINTON

SUN `13`

○ SCIENCE PARTY - RAHEEM'S HOUSE
□ BUY/BORROW EXTRA CHAIRS

TO DO (at some point)

■ START LAYING LAMINATE FLOORING
□ SORT BEDDING FOR SPARE ROOM
□ CHECK VISAS FOR HOLIDAY

EVERY SUCCESS STARTS WITH A DECISION TO.....

MON	TUE	WED	THU
3 MAY	4 MAY	5 MAY	6 MAY
24°	22°	18°	22°
WORK- MEETINGS	HALF DAY	WORK- PROCTOR	WORK- PROCTOR
▨ EMAIL FAULKS ▨ EMAIL JANICE ▨ EMAIL HEAD OFFICE ▷ SKYPE DONNIE	▨ CHECK YOUTUBE - PROCTOR PROJECT ▨ GO TO PAULA'S	○ AMELIA'S BIRTHDAY ▨ GET AIR CON REPAIRED	▨ SKYPE DONNIE ▨ CHECK PROCTOR LOGOS
GRATITUDE I LOVE THE SPRING BLOSSOM	GRATITUDE SNUGGLING WITH THE KIDS	GRATITUDE HEARING HARRIET SINGING	GRATITUDE LOVELY SUNSET
1 2 3 4 5 6 7 8 9 10 11 12 1 2 3 4 5 6 7 8 9 10 11 12	1 2 3 4 5 6 7 8 9 10 11 12 13 14 15 16 17 18 19 20 21 22 23 24	1 2 3 4 5 6 7 8 9 10 11 12 1 2 3 4 5 6 7 8 9 10 11 12	1 2 3 4 5 6 7 8 9 10 11 12 1 2 3 4 5 6 7 8 9 10 11 12
CHICKEN FAJITAS	NUT ROAST 8 VEGGIES	PULLED PORK + VEG	TAKE OUT. CHINESE

FRI	SAT	SUN	TO DO
7 MAY	8 MAY	9 MAY	
26°	21°	27°	
HALF DAY	HOUSE-WORK	BBQ	

FRI

⊗ GO TO TWIN LAKES WITH MAX

SAT

▷ CLEAN FRIDGE
▨ BATHROOM DUST VACUUM
▷ CLEAN WINDOWS

SUN

● IAN'S BBQ 12:00
▨ TAKE CHICKEN WINGS
▨ CLEAN FRIDGE
▷ CLEAN WINDOWS

TO DO

◁ GET AIR CON FIXED
▷ GO TO TWIN LAKES
▨ PROCTOR PROJECT
▨ CLEAN FRIDGE
▷ RESERVE TRAIN TICKETS

GRATITUDE

NIKITA'S "FASHION SHOW"

GRATITUDE

MY BEAUTIFUL DAUGHTER

GRATITUDE

GOOD FOOD WITH FRIENDS

DON'T **COUNT** the **DAYS** . . . MAKE the **DAYS COUNT**

MUHAMMAD ALI

1	2	3	4	5	6
7	8	9	10	11	12
1	2	3	4	5	6
7	8	9	10	11	12

1	2	3	4	5	6
7	8	9	10	11	12
13	14	15	16	17	18
19	20	21	22	23	24

1	2	3	4	5	6
7	8	9	10	11	12
1	2	3	4	5	6
7	8	9	10	11	12

BEEF + VEG WRAPS

SOUP + SALAD

SUNDAY ROAST

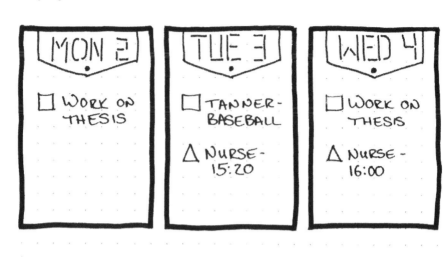

MON 2
- [] WORK ON THESIS

TUE 3
- [] TANNER- BASEBALL
- △ NURSE- 15:20

WED 4
- [] WORK ON THESIS
- △ NURSE- 16:00

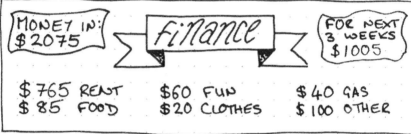

Finance

MONEY IN: $2075

FOR NEXT 3 WEEKS $1005

$765 RENT
$85 FOOD

$60 FUN
$20 CLOTHES

$40 GAS
$100 OTHER

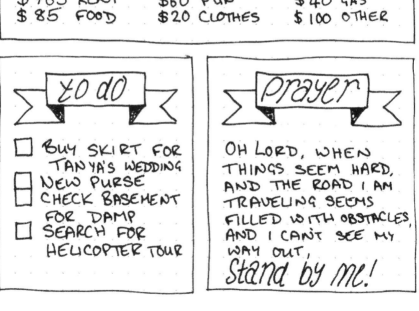

to do
- [] BUY SKIRT FOR TANYA'S WEDDING
- [] NEW PURSE
- [] CHECK BASEMENT FOR DAMP
- [] SEARCH FOR HELICOPTER TOUR

prayer
OH LORD, WHEN THINGS SEEM HARD, AND THE ROAD I AM TRAVELING SEEMS FILLED WITH OBSTACLES, AND I CAN'T SEE MY WAY OUT, *Stand by me!*

THU 5

FRI 6

☐ WORK ON
　　THESIS
O VISIT TO

SAT 7

O OLIVIA'S
　BIRTHDAY

SUN 8

☐ TANNER-
　　BASEBALL
O RILEY'S
　PARTY

Notes ☺

- OLIVIA WANTS TO
 START SWIMMING
 LESSONS

- THESIS NEEDS A
 THOROUGH PROOF READ-
 ASK ANDREW??

- BULLDOG PUPPIES
 FOR SALE IN
 DIXON STREET

March

M	T	W	T	F	S	S
						1
2	3	4	5	6	7	8
9	10	11	12	13	14	15
16	17	18	19	20	21	22
23	24	25	26	27	28	29
30	31					

MONDAY 6

8	
9	
10	WORK ON ZINC
11	PROJECT
12	
1	LUNCH WITH TONY
2	
3	3.20 PICK UP
4	RYAN
5	
6	RYAN - KARATE
7	
8	
9	
10	
11	

TUESDAY 7

8	O BARRY'S BIRTH DAY
9	
10	WORK ON
11	OXYGEN PROJECT
12	
1	
2	
3	
4	
5	
6	
7	
8	
9	
10	
11	

WEDNESDAY 8

8	
9	
10	
11	
12	
1	
2	
3	HANNAH.
4	
5	
6	RYAN - KARATE
7	
8	
9	
10	
11	

SUNDAY 12

7	O PETE'S
8	ANNIVERSARY
9	
10	
11	
12	
1	
2	
3	HANNAH'S
4	BBQ
5	
6	
7	
8	
9	
10	
11	

NOTES

- THERE MAY BE A MERGER AT WORK - READ UP ON PICKFORD'S.

- HANNAH SAYS SHE USED GCO FOR HAULAGE - GET MORE INFO?

- BRAMBLE AND CANDY'S CAGE IS GETTING SMALL FOR THEM.

☐ BUY LIPSTICK No. 34

THURSDAY 9

8	
9	
10	PLATINUM
11	PROJECT
12	
1	
2	
3	
4	
5	
6	SASHA-GYM
7	
8	
9	
10	
11	

FRIDAY 10

8	
9	
10	
11	
12	
1	LUNCH WITH
2	SARAH
3	
4	
5	
6	
7	
8	WORK - BLOG
9	+ INSTAGRAM
10	
11	

SATURDAY 11

8	
9	SASHA-
10	GYMNASTICS
11	
12	
1	
2	
3	
4	
5	
6	
7	
8	
9	
10	
11	

MEAL PLANNING

	BREAKFAST	LUNCH	DINNER
M	CEREAL	CHICKEN + SALAD	SPAGHETTI + MEATBALLS
T	CEREAL	SUB 6" - SPICY BEEF	GAMMON + FRIES
W	BAGELS	EGG SANDWICHES	CHICKEN + SPICY RICE
T	CEREAL	CHIPS + SAUSAGE	TAKE OUT PIZZA
F	CEREAL	CHICKEN + SALAD	FISH RISOTTO
S	PANCAKES	TURKEY + VEG WRAPS	EAT OUT
S	FULL ENGLISH	EAT OUT	CHICKEN, CARROTS & WEDGES

MON 8	TUE 9	WED 10	THU 11
☐ PHONE MIKE △ DR SAMSON 11.30	☐ SPEECH THERAPIST REPORT	☐ INSTA. ☐ FB ☐ TWITTER ☐ PINT.	☐ EMAIL MRS WU
☐ LAUNDRY (HANNAH) ☐ BATHROOM ☐ KITCHEN	☐ VACUUM DOWNSTAIRS	☐ LAUNDRY (DELICATES) ☐ VACUUM UPSTAIRS	☐ DUST IRONING
MIKE SAYS HE IS THINK-ING OF GOING TO PERU NEXT YEAR!	MISTY HAS MADE FRIENDS WITH A FAT GINGER TOM CAT!	FOUND THE MOST AMAZING HOT CHOC- NEXT TO RIPLEY'S.	HELEN IS SUDDENLY LOOKING REALLY PREGNANT.

FRI 12	SAT 13	SUN 14	BRAIN DUMP
☐ CHECK RATINGS OF TREE SURGEONS	O HANNAH'S BIRTHDAY, △ HANNAH'S PARTY 3pm	△ WENDY'S FOR LUNCH	WHY DO PEOPLE THINK IT'S OK TO JUMP LINES WHEN ANOTHER TILL OPENS?

A nice addition to a Weekly Log is a space to make a note of events that happened that day - like a mini diary. As you can see, it doesn't need to be anything profound or exciting; it can just be a little memory or thought.

☐ LAUNDRY (ME + CHIP) ☐ VACUUM DOWNSTAIRS	☐ VACUUM UPSTAIRS ☐ IRONING		○ ANNA KARENINA ○ ACROPOLIS ○ IRON AGE BRONZE AGE
TRIED RED ONION RELISH ON MY BURGER. DELISH!	DAD IS OFF PLAYING GOLF WITH SUE'S DAD = BROMANCE!	MONICA'S COCKA-POO PUPPY, TOBY, IS JUST ADORABLE!	
	NICE SHOT — THANKS		☐ CARD FOR PHIL ☐ CAT BASKET ☐ HEDGE QUOTES

71

october

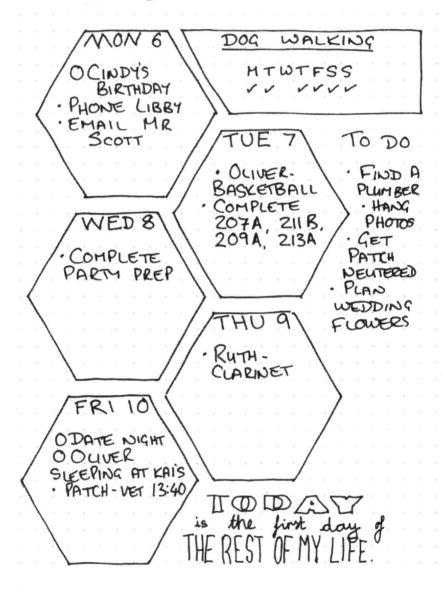

MON 6
- ○ CINDY'S BIRTHDAY
- · PHONE LIBBY
- · EMAIL MR SCOTT

DOG WALKING

M T W T F S S
✓ ✓ ✓ ✓ ✓

TUE 7
- · OLIVER-BASKETBALL
- · COMPLETE 207A, 211B, 209A, 213A

TO DO
- · FIND A PLUMBER
- · HANG PHOTOS
- · GET PATCH NEUTERED
- · PLAN WEDDING FLOWERS

WED 8
- · COMPLETE PARTY PREP

THU 9
- · RUTH-CLARINET

FRI 10
- ○ DATE NIGHT
- ○ OLIVER SLEEPING AT KAI'S
- · PATCH - VET 13:40

TODAY *is the first day of* THE REST OF MY LIFE.

SAT 11

○ LILA'S
BABY SHOWER

SUN 12

○ CHURCH
SALE 1400 →

Removable sticky notes such as Post-it notes make a really useful addition to your bullet journal. A great idea is to have a large one in your Weekly Log, to note down anything that you need to buy in for the following week. When you go to the store, you have a ready-made list to take with you.

MEAL PLAN

M	PASTA + MEATBALLS
T	PORK RIBS
W	FISH PIE
T	SPICY TACOS + DIPS
F	BURGER + FRIES
S	STIR FRY
S	BEEF STROGANOFF

LIFE
moves pretty fast
and if you don't stop
and
LOOK AROUND
once in a while you
could **MISS IT!**

TO BUY:

CANDY BARS
BROCCOLI
CARROTS
PARSNIPS
TORTILLAS
DOG FOOD
 - 10 CANS
 - 2 BAGS MIXER
TUNA
CHEESE
SHOWER GEL
PORK CHOPS
POTATOES
PASTA
PASTA SAUCE

APRIL

HOME | WORK

MON 15
- O OLIVER - BASKETBALL
- △ MEET JANINE 09:20
- △ MEETING - PENSIONS 14:50

TUE 16
- ☐ PHONE MOM
- △ MEET MEL - 10:40
- △ MEETING - MAILSHOT 13:45

WED 17
- △ MEET JANINE 09:30
- ☐ FINISH MERCER REPORT

THU 18
- ☐ PREPARE HOUSE FOR VISIT
- O VISIT FROM KADE'S SCHOOL

FRI 19
- O ALICIA'S BIRTHDAY
- O DATE NIGHT
- DATE
- △ MEET JANINE 10:20

SAT 20
- O KATIE'S DINNER 18:00

SUN 21
- △ JOINER - 09:40

FOOD

EGGPLANT PARM.

SPAG BOL

CHICKEN WRAPS

PASTA + MEATBALLS

TAKE OUT

SAUSAGE + MASH

STIR FRY

MONEY

$10 OLIVER'S BASKETBALL

$65 FOOD SHOP

$25 HOUSE STUFF
$30 ALCOHOL

$30 PIZZA

$45 GAS
$10 SNACKS

$100 TICKETS FOR SEGWAY

VOCAB

MASSAGE:
EL MASAJE

PEDICURE:
LA PEDICURA

HAIRCUT:
EL CORTE DE PELO

FINGERNAIL:
LA UÑA

KNUCKLE:
EL NUDILLO

FINGER:
EL DEDO

THUMB:
EL PULGAR

HAIR:
EL PELO

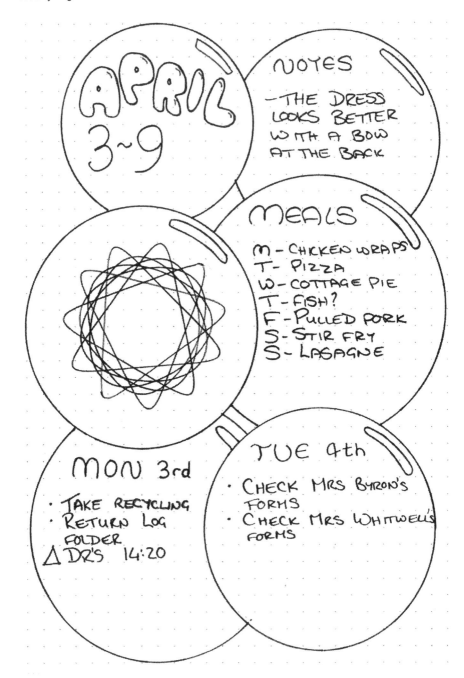

APRIL 3~9

NOTES

- THE DRESS LOOKS BETTER WITH A BOW AT THE BACK

MEALS

M - CHICKEN WRAPS
T - PIZZA
W - COTTAGE PIE
T - FISH?
F - PULLED PORK
S - STIR FRY
S - LASAGNE

MON 3rd

- TAKE RECYCLING
- RETURN LOG FOLDER
△ DR'S 14:20

TUE 4th

- CHECK MRS BYRON'S FORMS
- CHECK MRS WHITWELL'S FORMS

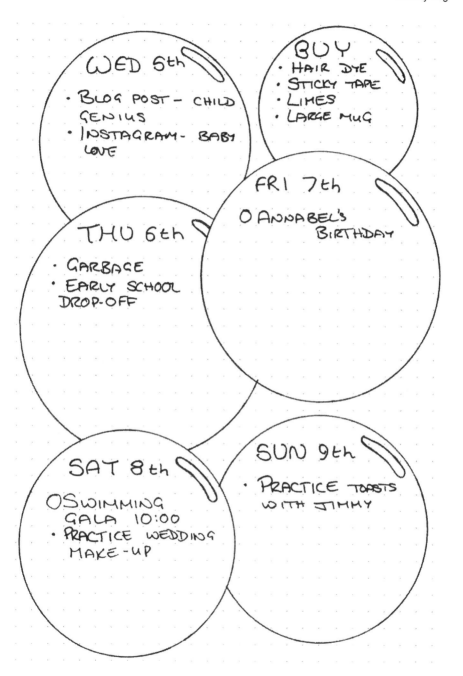

WED 5th
- BLOG POST — CHILD GENIUS
- INSTAGRAM — BABY LOVE

BUY
- HAIR DYE
- STICKY TAPE
- LIMES
- LARGE MUG

THU 6th
- GARBAGE
- EARLY SCHOOL DROP-OFF

FRI 7th
O ANNABEL's BIRTHDAY

SAT 8th
O SWIMMING GALA 10:00
- PRACTICE WEDDING MAKE-UP

SUN 9th
- PRACTICE TOASTS WITH JIMMY

MON 19
- O DATE NIGHT?

TUE 20
- O PIPPA'S DUE DATE
- ☒ PHONE PIPPA
- ☒ PHONE ROOFER
- △ BUILDER COMING 08:45

FAMILY DINNERS
- M SPAGHETTI + M. BALLS
- T CHICKEN WRAPS
- W SOUP
- T SAUSAGE + MASH
- F STIR FRY
- S GAMMON + WEDGES
- S EAT OUT

WED 21
- O EXTENSION STARTED £14,000 ESTIMATE

MY LUNCHES
- M CHICKEN SALAD
- T CHEESE SALAD
- W HOMMOUS + PITTA
- T SOUP + ROLL
- F PANINI
- S SOUP + ROLL
- S SALAD

THU 22
- △ MEET MISS BAKEWELL
- △ MEET MR CHU · 13:40

FRI 23
- O ROOFING STARTED

TO GOOGLE
- DIFFERENCE BETWEEN ACCEPT AND EXCEPT
- WHY MAMMOTHS BECAME EXTINCT

SAT 24
- O PIPPA GAVE BIRTH - "ELLIE-MAE"

SUN 25

MARCH 21-23

21st

>> MEET JANICE
X PAINT DADO RAIL IN HALL
O STARLIGHT EXPRESS - 7.30pm
>> PREPARE CAKE

22nd

X MEET JANICE
X COOK LUNCH
X PHONE E.E.
O JILL COMING FOR DINNER
X PREPARE CAKE

23rd

>> DADO RAIL 2ND COAT
X FOOD SHOP
X DECORATE CAKE
X GET PAINT CHIPS
△ DOCTORS - 9.45am
X MEET PAUL - 6.00pm

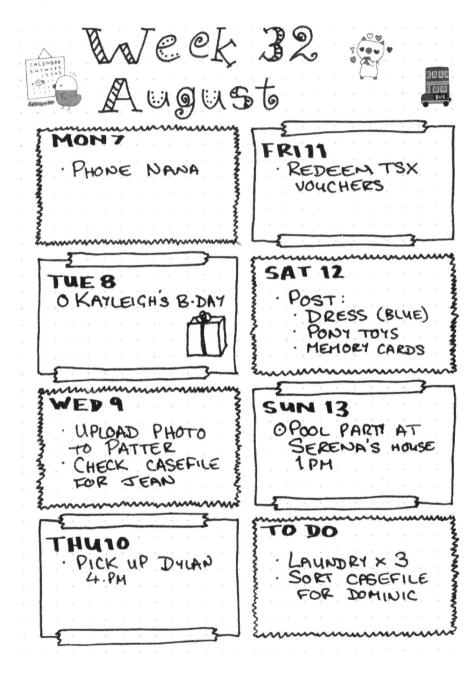

Week 32
August

MON 7
- PHONE NANA

TUE 8
O KAYLEIGH'S B-DAY

WED 9
- UPLOAD PHOTO TO PATTER
- CHECK CASEFILE FOR JEAN

THU 10
- PICK UP DYLAN 4-PM

FRI 11
- REDEEM TSX VOUCHERS

SAT 12
- POST:
 - DRESS (BLUE)
 - PONY TOYS
 - MEMORY CARDS

SUN 13
O POOL PARTY AT SERENA'S HOUSE 1PM

TO DO
- LAUNDRY × 3
- SORT CASEFILE FOR DOMINIC

MONDAY 11 **JUNE**

 PIZZA!

- ☒ PACK TOILETRIES
- ☒ GO FOOD SHOPPING
- ☒ MEET EMILY FOR LUNCH
- ☒ PLAN PRESENTATION - W.M.

72°/22°

I walked into work late and Harry said "Look what the cat dragged in" - my skirt was on back-to-front -- so embarrassing!!!

JUNE **TUESDAY 12**

- ☒ WHITE PAINT - DOOR?
- ✳ O AMANDA'S BIRTHDAY
- ☒ PHONE AMANDA

Elliot said he scored in hockey, and everyone gave him 3 cheers ". He forgot his Physics homework though "! He'll learn!

84°/29°

HIP HIP HOORAY FOR ELLIOT!

WEDNESDAY 13 **JUNE**

- ☒ PHONE BENTLEY'S PLUMBING
- O ANNIVERSARY - GRANDPA "
- ☒ PHONE DAD "

91°/33°

I rang Dad, and he'd actually forgotten what date it was. We took flowers to Grandpa's bench, and fed the birds. Today would have been too hot for Grandpa!

W/C 14 August

🎁 PDA
△ MR KAPOWSKI 9:00
△ MR ENGLAND 10:30
 △ MISS JACKSON 11:40

- BUY CHEESE
- BUY CREAM/ GREEN PAPER
- BUY FELT PENS
△ MR BRIAN 11:30
△ MISS BENTLEY 13:00

MON 14

TUE 15

- BUY LETTERING
- PUT OUT GARBAGE

FRI 18

△ MR BAGSHAW 11:00
△ MR + MRS DANIELS 12:00

THU 17

WED 16

O SAM + KIRSTEN'S ANNIVERSARY

△ MR JENNER 9:40
- BUY HOLE PUNCH
- POSTBOX PROJECT
- COLLECT RED WALL CLIPS

- COMPLETE JAGUAR PROJECT
- PHONE NIKKI
△ MISS SMITH 11:00
△ MR LAMB 12:30

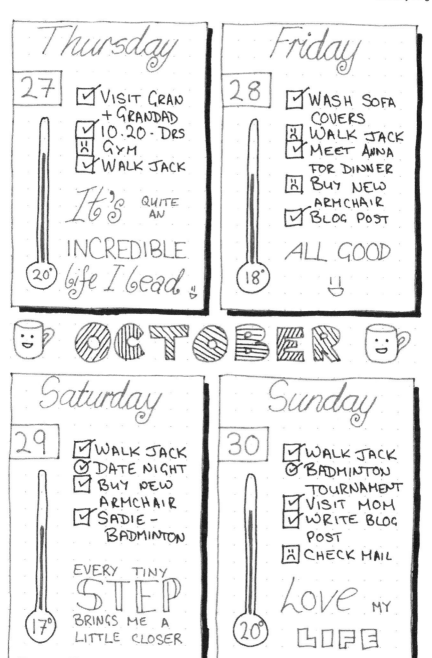

Thursday

27

- ☑ VISIT GRAN + GRANDAD
- ☑ 10.20 · DRS
- ☒ GYM
- ☑ WALK JACK

It's QUITE AN INCREDIBLE *life I lead.*

20°

Friday

28

- ☑ WASH SOFA COVERS
- ☒ WALK JACK
- ☑ MEET ANNA FOR DINNER
- ☒ BUY NEW ARMCHAIR
- ☑ BLOG POST

ALL GOOD

18°

OCTOBER

Saturday

29

- ☑ WALK JACK
- ☺ DATE NIGHT
- ☑ BUY NEW ARMCHAIR
- ☑ SADIE - BADMINTON

EVERY TINY STEP BRINGS ME A LITTLE CLOSER

17°

Sunday

30

- ☑ WALK JACK
- ☺ BADMINTON TOURNAMENT
- ☑ VISIT MOM
- ☑ WRITE BLOG POST
- ☒ CHECK MAIL

Love MY LIFE

20°

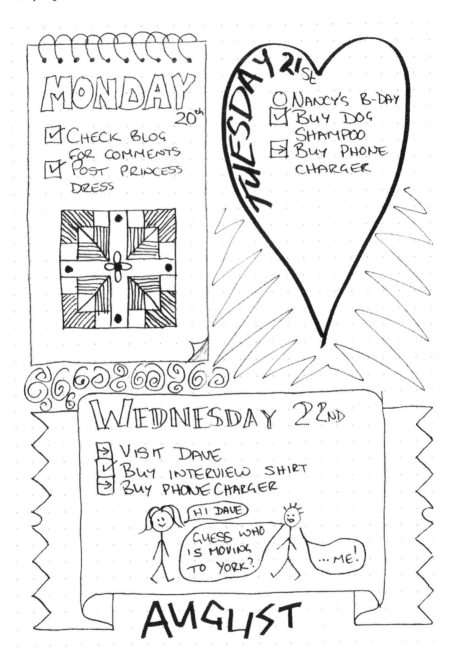

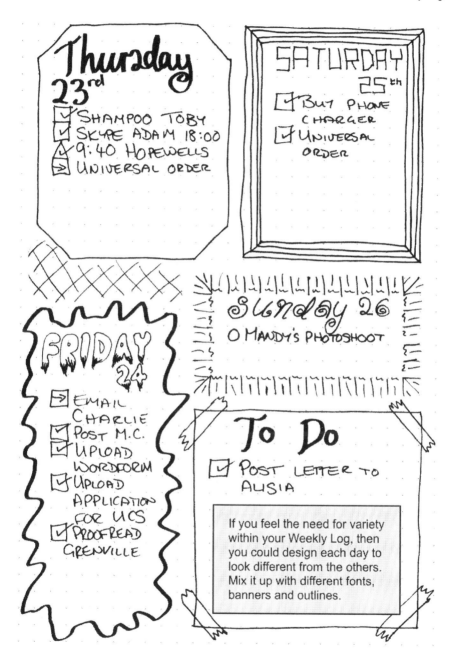

Thursday 23rd

- ☑ SHAMPOO TOBY
- ☑ SKYPE ADAM 18:00
- ☑ 9:40 HOPEWELLS
- ☒ UNIVERSAL ORDER

SATURDAY 25th

- ☑ BUY PHONE CHARGER
- ☑ UNIVERSAL ORDER

FRIDAY 24

- ☒ EMAIL CHARLIE
- ☑ POST M.C.
- ☑ UPLOAD WORDFORM
- ☑ UPLOAD APPLICATION FOR UCS
- ☑ PROOFREAD GRENVILLE

SUNDAY 26

O MANDY'S PHOTOSHOOT

To Do

- ☑ POST LETTER TO ALISIA

If you feel the need for variety within your Weekly Log, then you could design each day to look different from the others. Mix it up with different fonts, banners and outlines.

Monday

27

- ✗ Observe Katie 9.00
- ✗ Observe Ella 9.30
- ✗ Observe Lorraine 10.00
- ✗ Observe Casey 10.30
- → ✗ Observe Mike 11.00
- ✗ Meeting with HR 12.00
- ○ Lunch with Samir 12.30
- ✗ Meeting with Brian + Jake 1.30
- ✓ Work on Dyson presentation
- ✗ Josh - piano lesson 16.00
- ✗ Sebastian - trumpet lesson 15.00
- ✗ Gym - 19.00
- − Sebastian is preparing for grade 3 trumpet

EXERCISE	✓
H₂O	✓
PRAY	✓
YOGA	
☺ FOOD	✓
GRATITUDE	✓

Tuesday

28

- ✗ Meeting with Brian + Jake 9.00
- → ✗ Observe Carli 10.00
- ✗ Observe Martyn 10.30
- ✗ Observe James 11.00
- ✗ Observe Mark P. 11.30
- ✗ Meeting with assistant team leaders
- ○ Lunch with Casey 12.30
- → □ Proofread Dyson presentation
- ✓ Check specs for Jones-McLaughlin
- ✓ Write report on Greenworx
- → ✗ Gym - 19.00

EXERCISE		YOGA	
H₂O	✓	☺ FOOD	✓
PRAY	✓	GRATITUDE	✓

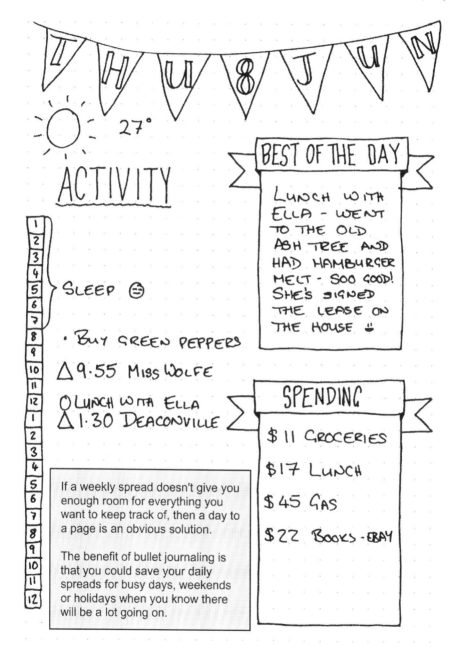

THU 8 JUN

27°

ACTIVITY

SLEEP ☺

• BUY GREEN PEPPERS
△ 9.55 MISS WOLFE
○ LUNCH WITH ELLA
△ 1.30 DEACONVILLE

BEST OF THE DAY

LUNCH WITH ELLA - WENT TO THE OLD ASH TREE AND HAD HAMBURGER MELT - SOO GOOD! SHE'S SIGNED THE LEASE ON THE HOUSE ☺

SPENDING

$11 GROCERIES
$17 LUNCH
$45 GAS
$22 BOOKS - EBAY

If a weekly spread doesn't give you enough room for everything you want to keep track of, then a day to a page is an obvious solution.

The benefit of bullet journaling is that you could save your daily spreads for busy days, weekends or holidays when you know there will be a lot going on.

Wednesday
27 JULY

To do

- ☒ TOY CARS
- ☒ 2G USB STICK
- ☒ PIGGY BANK
- · EMAIL THE BANK RE: VACATION
- · UPLOAD PICS
- · BUY NOTE PAD A5
- △ 15.50 MRS PRZEWORSKI

Meals

- · CHICKEN SALAD WRAP + CHIPS
- · SPAGHETTI BOLOGNESE

$$\frac{23°}{17°}$$

Journal

MRS PRZEWORSKI SAID SELINA IS STRUGGLING TO KEEP UP IN PHYSICS, AND MIGHT NEED TO MOVE DOWN TO GROUP 2. NOT WHAT WE NEED. ☹

1	2	3	4	5	6	7	8	9	10	11	12
1	2	3	4	5	6	7	8	9	10	11	12

◊ ◊ ◊ ◊ ◊ ◊ ◊

H_2O

QUOTE OF THE DAY

IF YOU WANT TO FEEL RICH, JUST COUNT ALL THE THINGS YOU HAVE THAT MONEY CAN'T BUY.
~ UNKNOWN

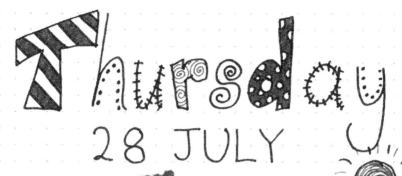

Thursday
28 JULY

To do

- ☒ BALL POOL
- ☒ GREEN TIES
- ☒ OPAL PENDANT
- ☒ UNIV. REMOTE
- ☒ DOLL CHAIRS
- • CHECK JULY STATS
- O MARCO'S BDAY
- • RING MARCO

MARCO'S BIRTHDAY

Meals
- SOUP + ROLL
- LAMB CURRY

26°
21°

Journal

MARCO CAME ROUND FOR DINNER; I GAVE HIM THE TICKETS FOR THE ODDBALLS AND HE WAS SO EXCITED!

QUOTE OF THE DAY

LIFE IS TOO SHORT TO STRESS OUT OVER PEOPLE WHO DON'T DESERVE ROOM IN YOUR HEART.
~ KAREN SALMANSOHN

1	2	3	4	5	6	7	8	9	10	11	12
1	2	3	4	5	6	7	8	9	10	11	12

 O O O O O O O O
H_2O

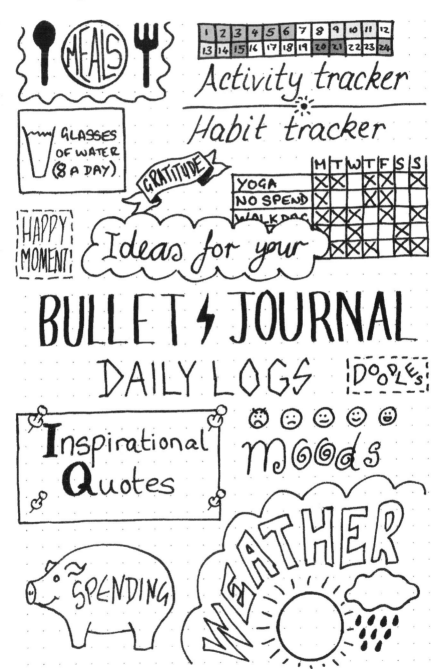

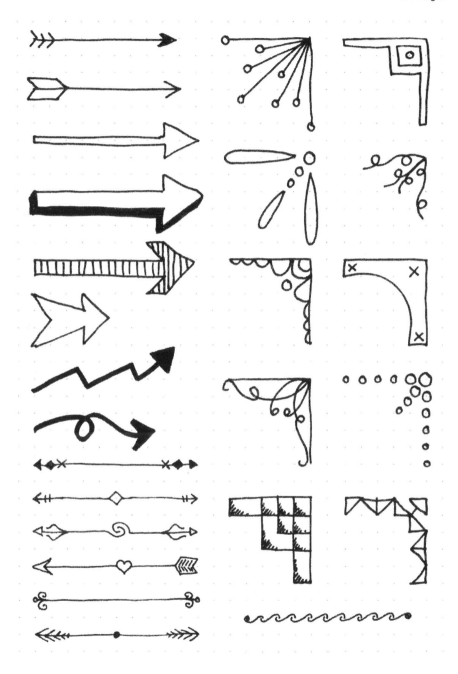

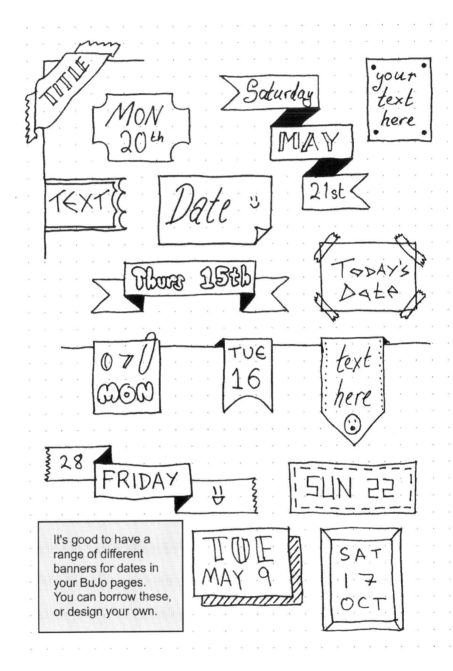

It's good to have a range of different banners for dates in your BuJo pages. You can borrow these, or design your own.

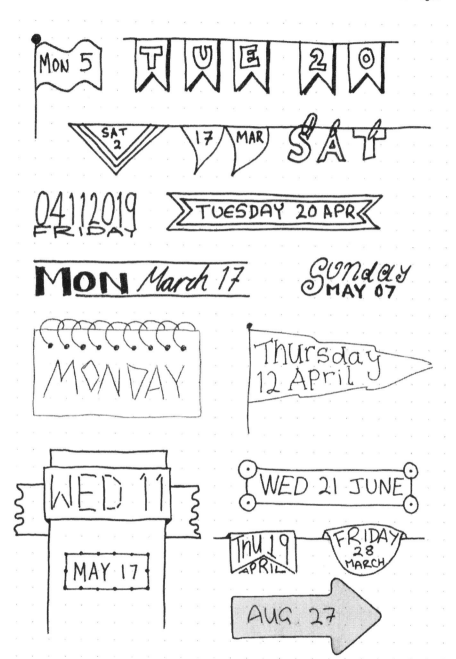

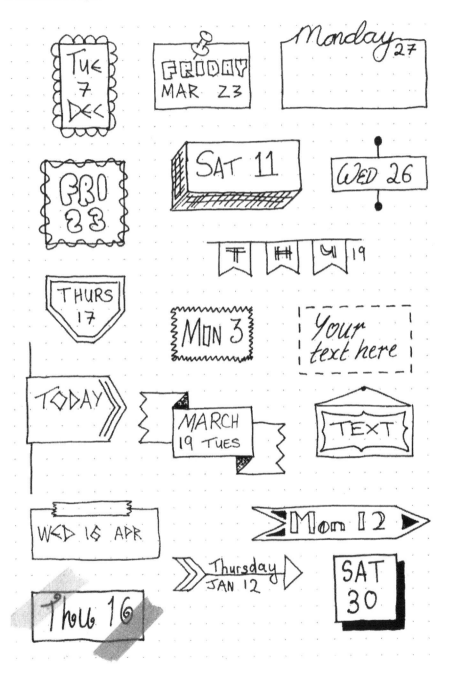

ICONS

Icons (or 'stickers') can convey information quickly and consist-ently. Plus little doodles can add a bit of interest to the page.

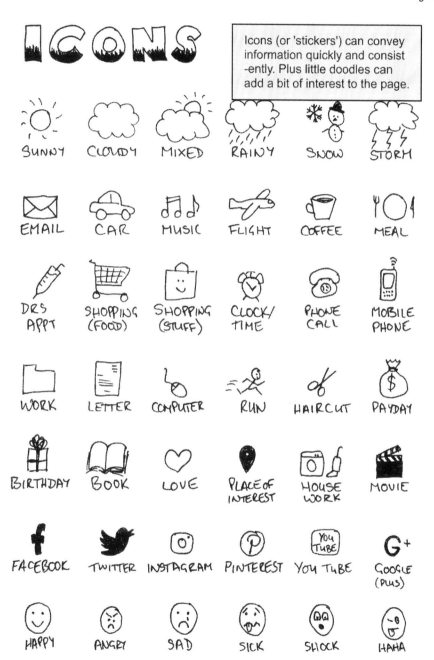

SUNNY CLOUDY MIXED RAINY SNOW STORM

EMAIL CAR MUSIC FLIGHT COFFEE MEAL

DRS APPT SHOPPING (FOOD) SHOPPING (STUFF) CLOCK/TIME PHONE CALL MOBILE PHONE

WORK LETTER COMPUTER RUN HAIRCUT PAYDAY

BIRTHDAY BOOK LOVE PLACE OF INTEREST HOUSE WORK MOVIE

FACEBOOK TWITTER INSTAGRAM PINTEREST YOU TUBE GOOGLE (PLUS)

HAPPY ANGRY SAD SICK SHOCK HAHA

Font idea 1 Aa Bb Cc

FONT IDEA 2 AB

FONT IDEA 3 ABCDEFG

Font idea 4 Aa Bb CcDd

FONT IDEA 5 A B C D E

FONT IDEA 6 A BCD

FONT IDEA 7 ABCDEFGHIJKLMNOPQRST

Font idea 8 Aa Bb Cc

FONT IDEA 9 ABCDE

font idea 10 AaBbCc

FONT IDEA 11 ABC

FONT IDEA 12 AB

Font idea 13 AaBbC

Stencil Font Aa Bb Cc Dd E

Stencil Font2 Aa B

STENCIL 3

STENCI

FONT IDEA 14 ABCDEFGHIJKLM

FONT idEA 15 Aa Bb C

font idea 16 Aa Bb Cc

Font idea 17 Aa Bb Cc

FONT IDEA 18 ABCDEF

Font idea 19 Aa

Birthdays

JANUARY
M	T	W	T	F	S	S
					1	2
3	4	5	6	7	8	9
10	11	12	13	14	15	16
17	18	19	20	21	22	23
24	25	26	27	28	29	30
31						

FEBRUARY
M	T	W	T	F	S	S
	1	2	3	4	5	6
7	8	9	10	11	12	13
14	15	16	17	18	19	20
21	22	23	24	25	26	27
28						

MARCH
M	T	W	T	F	S	S
	1	2	3	4	5	6
7	8	9	10	11	12	13
14	15	16	17	18	19	20
21	22	23	24	25	26	27
28	29	30	31			

APRIL
M	T	W	T	F	S	S
				1	2	3
4	5	6	7	8	9	10
11	12	13	14	15	16	17
18	19	20	21	22	23	24
25	26	27	28	29	30	

MAY
M	T	W	T	F	S	S
						1
2	3	4	5	6	7	8
9	10	11	12	13	14	15
16	17	18	19	20	21	22
23	24	25	26	27	28	29
30	31					

JUNE
M	T	W	T	F	S	S
		1	2	3	4	5
6	7	8	9	10	11	12
13	14	15	16	17	18	19
20	21	22	23	24	25	26
27	28	29	30			

JULY
M	T	W	T	F	S	S
				1	2	3
4	5	6	7	8	9	10
11	12	13	14	15	16	17
18	19	20	21	22	23	24
25	26	27	28	29	30	31

AUGUST
M	T	W	T	F	S	S
1	2	3	4	5	6	7
8	9	10	11	12	13	14
15	16	17	18	19	20	21
22	23	24	25	26	27	28
29	30	31				

SEPTEMBER
M	T	W	T	F	S	S	
				1	2	3	4
5	6	7	8	9	10	11	
12	13	14	15	16	17	18	
19	20	21	22	23	24	25	
26	27	28	29	30			

OCTOBER
M	T	W	T	F	S	S
					1	2
3	4	5	6	7	8	9
10	11	12	13	14	15	16
17	18	19	20	21	22	23
24	25	26	27	28	29	30
31						

NOVEMBER
M	T	W	T	F	S	S
	1	2	3	4	5	6
7	8	9	10	11	12	13
14	15	16	17	18	19	20
21	22	23	24	25	26	27
28	29	30				

DECEMBER
M	T	W	T	F	S	S	
				1	2	3	4
5	6	7	8	9	10	11	
12	13	14	15	16	17	18	
19	20	21	22	23	24	25	
26	27	28	29	30	31		

Birthdays

JAN 17 : AMY
JAN 27 : JENNY C
FEB 2 : ELIJAH
FEB 24 : MOM
FEB 28 : SOPHIA
MAR 19 : ANDY
MAR 24 : MONICA
MAR 28 : PAULINE
APR 1 : BRUCE
APR 2 : GRANDMA
APR 13 : ERICA
APR 29 : JENNY D.
MAY 4 : AMELIA
MAY 6 : LEILA-MAE
JUN 26 : SHAMEDRIA
JUL 15 : BARON
JUL 17 : DAD
AUG 9 : JAMIE
AUG 16 : CELINE
AUG 24 : ARLIA
SEP 1 : JOSH
OCT 10 : MIKE
OCT 14 : JACOB M.
OCT 25 : JAMIL
OCT 27 : PATRICK
OCT 30 : MEL
NOV 9 : RAHEEM
NOV 29 : JACOB B.
DEC 17 : ALBA
DEC 29 : LUCY

If you have a lot of birthdays to keep track of, or if you are finding it intrusive to keep on writing them out into every Future, Monthly and Daily Log, then a page dedicated to just birthdays (and anniversaries) may be the answer. You just have to remember to keep checking it!

Here, a visual calendar has been combined with a simple list of dates and names.

I WANT TO READ THIS YEAR

- 100 YEARS OF SOLITUDE 🙂
- BAD SCIENCE - GOLDACRE
- WAR AND PEACE
- REPUBLIC - PLATO
- MACBETH - SHAKESPEARE 🙂
- A MIDSUMMER NIGHT'S DREAM - SHAKES.
- PRIDE AND PREJUDICE 🙂
- CAN A ROBOT BE HUMAN? 🙂
- 50 PSYCHOLOGY IDEAS 🙁
- THE GOD DELUSION - DAWKINS 🙂
- ORIGIN OF SPECIES - DARWIN
- AS YOU LIKE IT - SHAKESPEARE
- 50 SHADES OF GREY 😨

Books

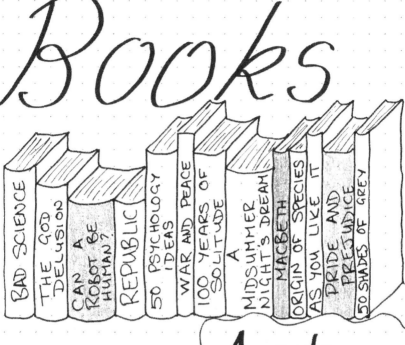

BAD SCIENCE · THE GOD DELUSION · CAN A ROBOT BE HUMAN? · REPUBLIC · 50 PSYCHOLOGY IDEAS · WAR AND PEACE · 100 YEARS OF SOLITUDE · A MIDSUMMER NIGHT'S DREAM · MACBETH · ORIGIN OF SPECIES · AS YOU LIKE IT · PRIDE AND PREJUDICE · 50 SHADES OF GREY

You can use your BuJo for anything you choose: here are two ideas for how to keep track of books to read.

On the opposite page, squares are colored in to indicate how much of the book has been read, and a line drawn through the boxes to show the book was given up on; the smiley faces are a quick review system.

On this page, books are colored in to show they have been read.

A reader lives 1,000 lives before he dies. The man who never reads lives only 1.

LEVEL 10 LIFE

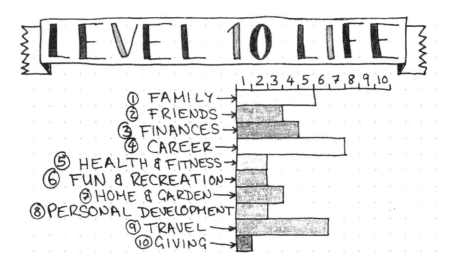

1 2 3 4 5 6 7 8 9 10

① FAMILY
② FRIENDS
③ FINANCES
④ CAREER
⑤ HEALTH & FITNESS
⑥ FUN & RECREATION
⑦ HOME & GARDEN
⑧ PERSONAL DEVELOPMENT
⑨ TRAVEL
⑩ GIVING

GOAL TRACKING

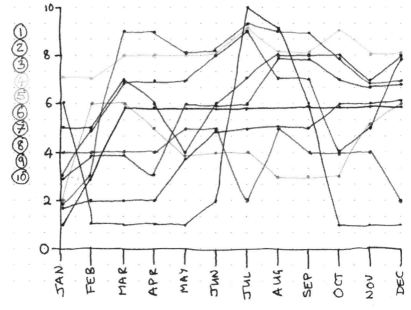

MY LEVEL 10 GOALS

1. KEEP IN TOUCH WITH SAM & BARBARA ONCE A MONTH. PLAY WITH THE KIDS EVERY DAY.

2. MEET A FRIEND FOR LUNCH ONCE A WEEK. SOCIALISE ONE EVENING PER WEEK.

3. PAY OFF MY STUDENT LOAN. PAY OFF CREDIT CARDS. SAVE FOR EUROPE TRIP.

4. BE EMPLOYEE OF THE MONTH. ARRIVE ON TIME EVERY DAY. ACHIEVE 5* IN MY REVIEW.

5. RUN 5K ONCE PER WEEK. JOIN A GYM AND VISIT 2x PER WEEK. LOSE 30lb

6. GO ON A FUN TRIP ONCE EVERY 2 WEEKS. HAVE 30 MINS "ME" TIME EVERY DAY.

7. REDECORATE BATHROOM. KEEP ON TOP OF WEEDS IN GARDEN. VACUUM EVERY WEEK.

8. READ AN ACADEMIC / CLASSIC BOOK EACH MONTH. LEARN A NEW SKILL 2x PER YEAR.

9. VISIT A NEW COUNTRY EACH YEAR. GO ON A ROAD TRIP TO 5 NEW STATES.

10. DONATE TO A CHARITY BY STANDING ORDER. VOLUNTEER AT A LOCAL SHELTER

The graph on the opposite page makes a lot more sense when a different color is assigned to each of the 10 goals.

Level 10 Goals

1 FAMILY + FRIENDS • SEE FRIENDS
• FAMILY TIME EACH DAY EACH WEEK

2 MARRIAGE • ADULT TIME 3x/WEEK
• DATE NIGHT EACH WEEK

3 SPIRITUALITY • PRAY EVERY DAY
• VISIT CHURCH EVERY SUNDAY

4 GIVING • GIVE $5/MONTH TO CHARITY
• VOLUNTEER AT A SHELTER

5 FINANCES • STOP NEEDLESS SHOPPING
• SAVE $50+ PER MONTH

6 CAREER • BE PRODUCTIVE EACH DAY
• ACHIEVE LEVEL 4

7 HEALTH + FITNESS • GYM 2x A WEEK
• RUN 10K IN UNDER 55 MINS

8 HOME + GARDEN • COMPLETE KITCHEN
• RENOVATE KIDS' ROOMS

9 FUN + RECREATION • DAY TRIP 2x
• TRY NEW SPORTS PER MONTH

10 PERSONAL DEVELOPMENT • IMPROVE MY
• LEARN JAPANESE COOKING

Level 10 Life

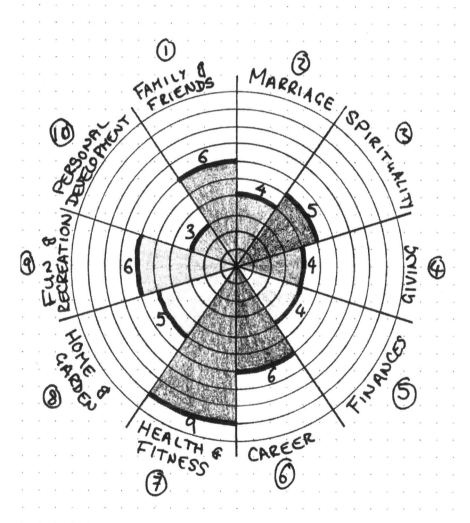

EXERCISE LOG

Columns: CRUNCHES | ABS | PRESS UPS | LUNGES | PULL-UPS | PLANK | BRIDGES | SQUATS | LEG RAISES | ROWING | JUMPING JACKS | WALL SIT | ARCHES | BENCH PRESS | 1k RUN | ~2k RUN | ~5k RUN | ~10k RUN

Rows:
1 T
2 W
3 T
4 F
5 S
6 S
7 M
8 T
9 W
10 T
11 F
12 S
13 S
14 M
15 T
16 W
17 T
18 F
19 S
20 S
21 M
22 T
23 W
24 T
25 F
26 S
27 S
28 M
29 T
30 W

Exercise is my friend

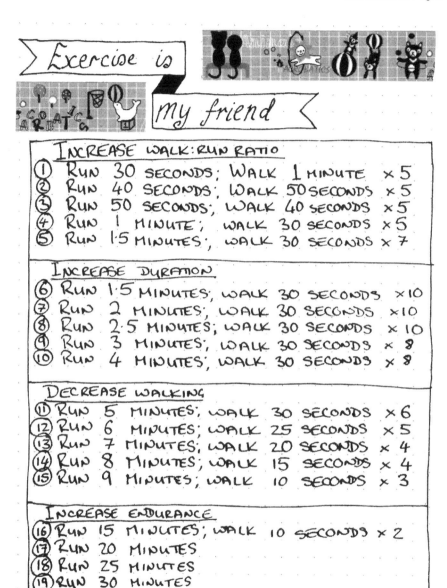

Increase Walk:Run Ratio

1. Run 30 seconds; Walk 1 minute × 5
2. Run 40 seconds; Walk 50 seconds × 5
3. Run 50 seconds; Walk 40 seconds × 5
4. Run 1 minute; Walk 30 seconds × 5
5. Run 1·5 minutes; Walk 30 seconds × 7

Increase Duration

6. Run 1·5 minutes; Walk 30 seconds × 10
7. Run 2 minutes; Walk 30 seconds × 10
8. Run 2·5 minutes; Walk 30 seconds × 10
9. Run 3 minutes; Walk 30 seconds × 8
10. Run 4 minutes; Walk 30 seconds × 8

Decrease Walking

11. Run 5 minutes; Walk 30 seconds × 6
12. Run 6 minutes; Walk 25 seconds × 5
13. Run 7 minutes; Walk 20 seconds × 4
14. Run 8 minutes; Walk 15 seconds × 4
15. Run 9 minutes; Walk 10 seconds × 3

Increase Endurance

16. Run 15 minutes; Walk 10 seconds × 2
17. Run 20 minutes
18. Run 25 minutes
19. Run 30 minutes
20. Run 35 minutes

Get off the couch and go running ☺

MY 5k CHALLENGE

CURRENT: 36 MINS ➡️ **TARGET: 20 MINS**

Time in Minutes: 36, 35, 34, 33, 32, 31, 30, 29, 28, 27, 26, 25, 24, 23, 22, 21, 20, 19

Dates: 5 SEP, 12 SEP, 19 SEP, 26 SEP, 3 OCT, 10 OCT, 17 OCT, 24 OCT, 31 OCT, 7 NOV, 14 NOV, 21 NOV, 28 NOV, 5 DEC, 12 DEC, 19 DEC, 26 DEC, 2 JAN, 9 JAN, 16 JAN, 23 JAN, 30 JAN, 6 JAN, 13 JAN

Whether you're trying to save money, lose weight or write a novel, keeping a written record of your progress can be a great motivator.

Plotting your progress on a graph such as this can really help you see how far you've come (and how far you still have to go!)

GREAT PB's
24 OCT - UNDER 35 MINS
14 NOV - 33:26
12 DEC - 31:09

9 JAN :- 29:28
30 JAN - 27:41

Weight loss

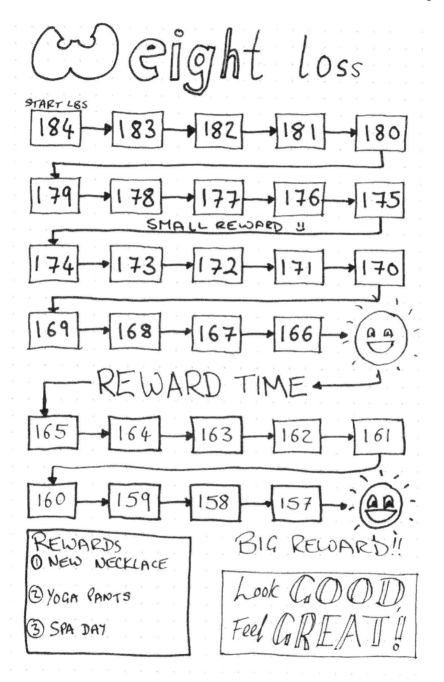

START LBS

184 → 183 → 182 → 181 → 180

179 → 178 → 177 → 176 → 175

SMALL REWARD !!

174 → 173 → 172 → 171 → 170

169 → 168 → 167 → 166 → 😄

REWARD TIME ←

165 → 164 → 163 → 162 → 161

160 → 159 → 158 → 157 → 😄

BIG REWARD!!

REWARDS
① NEW NECKLACE
② YOGA PANTS
③ SPA DAY

Look GOOD
Feel GREAT!

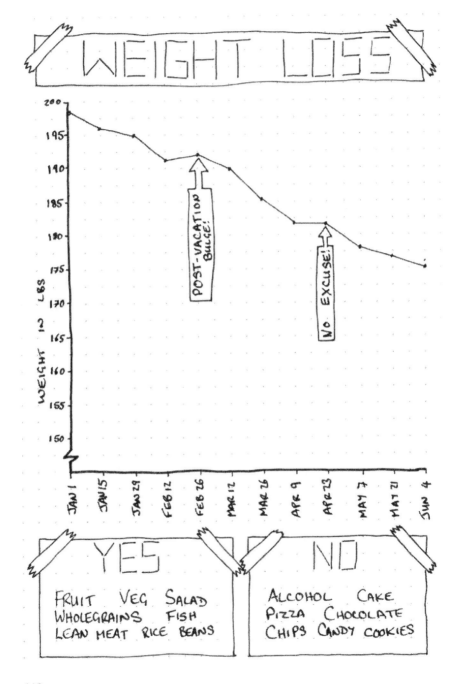

MONTHLY review

BULLET ⚡ JOURNAL

WHAT WENT WELL

- MONTHLY ACTIVITY TRACKER
- WEEKLY GOALS
- MEAL PLANNER
- DAILY SPENDING LOG
- SPACE FOR JOURNALING
- EXERCISE LOG

IMPROVEMENTS

GET RID OF
- WEEKLY ACTIVITY TRACKER
- WEATHER
- NOTES

TRY
- VERTICAL LAYOUT
- WASHI TAPE

LIFE ☺

WHAT WENT WELL

- EXERCISE
- SOCIAL LIFE
- WORKLOAD

IMPROVEMENTS

- SPEND LESS TIME EMAILING
- MORE TIME WITH FAMILY / KIDS
- DIET

A useful idea, particularly when you are experimenting, is to have a monthly review like this: just ditch what isn't working any more.

Ladytime TRACKER

JAN	FEB	MAR	APR	MAY	JUN	JUL	AUG	SEP	OCT	NOV	DEC
1	1	1	1	1	1	[1]	[1]	1	1	1	1
2	2	2	2	2	2	[2]	2	2	2	2	2
3	3	3	3	[3]	[3]	[3]	3	3	3	3	3
4	4	4	4	[4]	[4]	[4]	4	4	4	4	4
5	5	5	5	[5]	[5]	[5]	5	5	5	5	5
6	6	6	6	[6]	[6]	6	6	6	6	6	6
7	7	7	7	[7]	[7]	7	7	7	7	7	7
8	8	8	[8]	[8]	[8]	8	8	8	8	8	[8]
9	9	9	[9]	[9]	9	9	9	9	9	9	[9]
10	10	10	[10]	[10]	10	10	10	10	10	10	[10]
11	11	[11]	[11]	11	11	11	11	11	11	[11]	[11]
12	[12]	[12]	[12]	12	12	12	12	12	12	[12]	[12]
13	[13]	[13]	[13]	13	13	13	13	13	13	[13]	[13]
14	[14]	[14]	14	14	14	14	14	14	14	[14]	[14]
15	[15]	[15]	15	15	15	15	15	15	15	[15]	15
[16]	[16]	[16]	16	16	16	16	16	16	[16]	[16]	16
[17]	[17]	17	17	17	17	17	17	17	[17]	17	17
[18]	[18]	18	18	18	18	18	18	18	[18]	18	18
[19]	19	19	19	19	19	19	19	[19]	[19]	19	19
[20]	20	20	20	20	20	20	20	[20]	[20]	20	20
[21]	21	21	21	21	21	21	21	[21]	[21]	21	21
22	22	22	22	22	22	22	[22]	[22]	[22]	22	22
23	23	23	23	23	23	23	[23]	[23]	23	23	23
24	24	24	24	24	24	24	[24]	[24]	24	24	24
25	25	25	25	25	25	25	[25]	25	25	25	25
26	26	26	26	26	26	26	[26]	26	26	26	26
27	27	27	27	27	27	[27]	[27]	27	27	27	27
28	28	28	28	28	28	[28]	28	28	28	28	28
29		29	29	29	29	[29]	29	29	29	29	29
30		30	30	30	[30]	[30]	30	30	30	30	30
31		31		31		[31]	31		31		31

Ladytime Tracker

PREDICTED DATE	ACTUAL DATE	NO. OF DAYS IN CYCLE	PAIN 0-10
FEB 12	FEB 12	27	2
MAR 11	MAR 11	27	2
APR 7	APR 8	28	4
MAY 5	MAY 4	26	3
MAY 31	JUN 3	30	5
JUN 30	JUN 30	27	2
JUL 27	JUL 27	27	2
AUG 23	AUG 22	26	2
SEP 18	SEP 19	28	4
OCT 16	OCT 16	27	6
NOV 12	NOV 11	26	3
DEC 8	DEC 8	27	2
JAN 4	JAN 5	28	4
FEB 1	FEB 1	27	3

MONEY tracking

Mortgage — 1st of month

J	F	M	A	M	J	J	A	S	O	N	D
225	225	225	225	225	225	225	225	225	225	225	225

Gas & Electric — 1st. quarterly

J	F	M	A	M	J	J	A	S	O	N	D
	479			470			407			423	

Sky — 26th of month

J	F	M	A	M	J	J	A	S	O	N	D
32	32	32	32	32	32	32	32	32	26	26	26

Mobile — 31/30 of month

J	F	M	A	M	J	J	A	S	O	N	D
26	33	41	32	30	24	26	29	27	27	26	34

Car repayments — 1st of month

J	F	M	A	M	J	J	A	S	O	N	D
105	105	105	105	105	105	947					

TOTALS

J	F	M	A	M	J	J	A	S	O	N	D
383	874	403	394	862	386	1230	693	284	278	700	285

To create a savings layout like this, simply draw out blocks representing an amount of cash, and color it in when you've saved it.

Save, Save, Save

DO NOT SAVE WHAT IS LEFT AFTER SPENDING. INSTEAD, SPEND WHAT IS LEFT AFTER SAVING.
WARREN BUFFET

CONTINGENCY

£20 £40 £60 £80 £100
£120 £140 £160 £180 £200
£220 £240 £260 £280 £300
£320 £340 £360 £380 £400

PAYING OFF CREDIT CARDS

£100	£200	£300	£400	£500
£600	£700	£800	£900	£1,000

SAVING FOR ITALY

£500
£466
£433
£400
£366
£333
£300
£266
£233
£200
£166
£133
£100
£66
£33

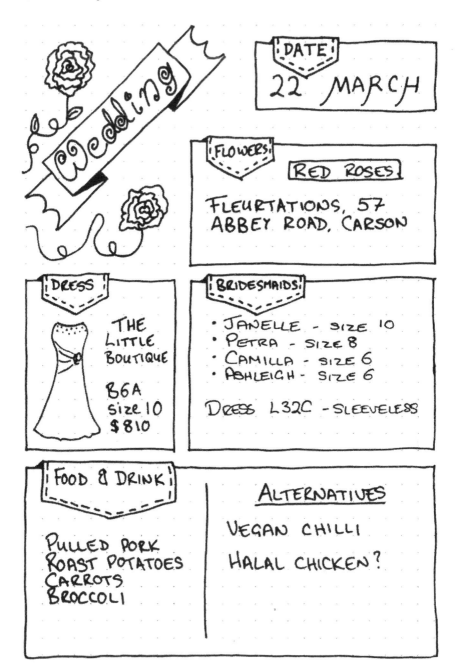

Wedding

DATE

22 MARCH

FLOWERS

RED ROSES

FLEURTATIONS, 57 ABBEY ROAD, CARSON

DRESS

THE LITTLE BOUTIQUE

B6A Size 10 $810

BRIDESMAIDS

- JANELLE - SIZE 10
- PETRA - SIZE 8
- CAMILLA - SIZE 6
- ASHLEIGH - SIZE 6

DRESS L32C - SLEEVELESS

FOOD & DRINK

PULLED PORK
ROAST POTATOES
CARROTS
BROCCOLI

ALTERNATIVES

VEGAN CHILLI

HALAL CHICKEN?

Done/Booked	Paid		
✓	✓	VENUE — OLD LODGE HALL	
✓	✓	INVITATIONS — WEDDINGS 4U	
✓	✓	FAVORS — CHOCOLATE BOX	
✓	■	GIFT LIST — GIFTLISTONLINE	
✓		CAKE — LUCY'S SPECIALITY	
✓		FLOWERS — FLEURTATIONS	
✓	✓	DRESS — THE LITTLE BOUTIQUE	
		ACCESSORIES	
✓		HAIR — JEAN-PIERRE LECLERC	
		MAKE-UP	
		RINGS	
✓	✓	SUITS — J.P.S. ELEGANTS	
✓	✓	SHOES (ME) — SHOETIFUL	
✓	✓	BRIDESMAID DRESSES — THE LITTLE BOUTIQUE	
✓		CARS — BRAXTERS VEHICLES	
	■	SONGS	
		PRAYERS	
	■	PLACE CARDS/MENUS	
		SEATING CHART	
✓		MANICURE — NAILS + TANS AT HOME	
✓	✓	CHAMPAGNE	
		JEWELRY	
✓		PHOTOGRAPHER	

HONEYMOON

GOA? BALI? DUBAI?

Summer FUN

TREASURE HUNT	SLIP 'N' SLIDE
BLOW BUBBLES	FAIRY GARDEN
FEED THE DUCKS	HIDE 'N' SEEK
DECORATE SHIRTS	STARGAZING
BIKE RIDE	DRAW COMICS
ORIGAMI	PICNIC
MAKEOVERS	PLAY TAG
BUILD A DEN	ZOO
WATER FIGHT	SHADOW PUPPETS
PAINT PICTURES	MAKE PLAY-DOUGH
CAT'S CRADLE	COOK S'MORES
CUPCAKES	CLIMB TREES
PLAYGROUND	JUGGLE
PUPPET SHOW	DAYTIME DISCO
GROW SUNFLOWERS	HOPSCOTCH
FOOTBALL	GROW A FROG
FARM VISIT	BUILD A MINI TOWN
FRISBEE	GEOCACHING
TEA PARTY	FLY A KITE
MAGIC SHOW	PILLOW FIGHT
BARBECUE	WATER BALLOONS
MAKE ICE CREAM	PLAY WITH A DOG
SIDEWALK CHALK	BERRY PICKING
DRESS UP	PAINT ROCKS
CAMP IN THE YARD	BOARD GAMES
BALLOON VOLLEYBALL	SWIMMING

KONMARI METHOD

Go through every object I own and decide whether to keep it or not

Does it spark joy? Is it necessary? Does it work?

If not, then thank it for its service, and discard it.

Tidy by theme, not by room. Tidy once. Tidy intensely and ruthlessly.

Follow the correct order:
1. Clothes
2. Books
3. Papers
4. Stuff
5. Sentimental

Everything needs a designated place where it can be put away

Fold clothes properly

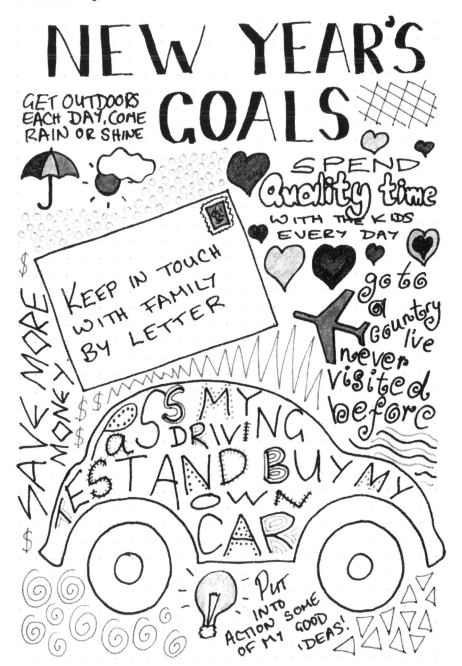

KEY

- TASK TO DO
- ~~TASK ABANDONED~~
- X TASK COMPLETE
- ˅ TASK MOVED FORWARD
- O EVENTS
- — NOTES
- ‹ TASK MIGRATED

SIGNIFIERS
* IMPORTANT

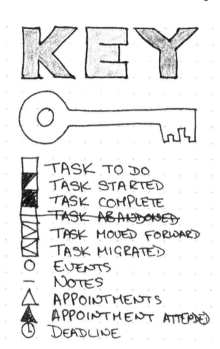

☐	TASK TO DO
◪	TASK STARTED
◼	TASK COMPLETE
~~TASK ABANDONED~~	
▷	TASK MOVED FORWARD
⊠	TASK MIGRATED
O	EVENTS
—	NOTES
△	APPOINTMENTS
▲	APPOINTMENT ATTENDED
◷	DEADLINE

Key

☐	TASK TO DO
	~~TASK ABANDONED~~
◪	TASK STARTED
⊠	TASK COMPLETE
☑→	TASK RE·SCHEDULED
⌕	SEARCH THIS
◷	DEADLINE
!	URGENT
✉	EMAIL
★	IMPORTANT
△	MEETING
✚	DOCTOR/HOSPITAL
$	BUY

It's a good idea to write yourself a key at the front or back of your bullet journal. The key suggested by Ryder Carroll is shown here on the top left. Many people in the BuJo online communities have created their own keys such as boxes which are ticked off or filled in when a task is completed. You can of course create your own symbols to stand for things which you want to write regularly, such as pay day, deadlines, birthdays, meetings and so on.

121

PAGE IDEAS FOR YOUR BULLET JOURNAL

Achievements (resume / CV)

Addresses

Albums / bands to listen to

Anniversaries

Baby names

Bills

Birthday present ideas for others

Birthdays

Book ideas

Books you want to read / have read

Brainstorming

Bucket list

Christmas list / wishlist

Craft ideas

Diet tracker

DIY planning

Doodles

Emergency checklist

Exercise log

Favorite songs

Friends

Glasses of water consumed

Gratitude log

Habit tracker

Hashtags to follow on social media

Holiday packing list

Instant message conversations

Insurance details

Jokes

Life goals

Meal planner / tracker

Mood boards

New year's resolutions

Overheard conversations

Party ideas

Passwords (in code)

Pinterest ideas

Places to visit / visited

Practice fonts / banners / colors

Prayers

Quotes

Recipes to try

Restaurants to try

Revision techniques

Savings tracker

Shopping lists

Sleep log

Snack tracker

Spending tracker

Study targets

Things to read up on

Tradesmen you've used

TV programs / box sets you want to watch

Useful phone numbers

Washi tape

Weather

Weekly timetable / appointments

STICKERS USED IN THIS BOOK

All stickers used in this book were purchased from eBay, though they are also available from other websites and in stationery shops.

Planner stickers

Planner stickers

Bonjour Cochonn stickers
(often listed as 'cute pig stickers')

Planner stickers
(often listed as 'cute cat stickers')

USEFUL PHYSICAL RESOURCES

Leuchtturm 1917 dotted A5

Moleskine dotted A5

Bullet journal

Staedtler fineliner pens

Stabilo fineliner pens

Washi tape

USEFUL ONLINE RESOURCES

The following details were all correct at the time of going to print, but as with anything digital, it can change in the blink of an eye!

Websites and Blogs

www.bulletjournal.com

www.bohoberry.com

www.bulletjournal.com/blog/

www.tinyrayofsunshine.com

www.bulletjournaljoy.com

Pinterest

Accounts

@bulletjournal @bujocollection @bulletjournals

@bullet-journal-collaborative-board

Boards

@bethmoneal (board: Bullet Journal Inspiration)

@tamingtwins (board: Bullet Journal Journey)

@thebigAword (board: Bullet Journals)

@readingres (board: Bullet Journal)

@suzh85 (board: Bullet Journaling)

@shericar (board: Bullet Journal)

Instagram

Hashtags

#bujo

#bujocommunity

#bujolove

#bujojunkies

#bujotracker

#bulletjournal

#bulletjournaljunkies

#bulletjournaling

#bulletjournallove

Boards

@bulletjournaljoy

@tinyrayofsunshine

@boho.berry

@bulletjournal

Facebook

Pages / groups

Bullet Journal Fan Site

Bullet Journal Junkies

Bullet Journal

Bullet journal professionals

Twitter

People

@rydercarroll

@BohoBerry

@tinyrayofsun

Hashtags

#bulletjournal

#bujo

#planwithmechallenge

#bujojunkies

#bujolove

#bulletjournalpages

REFERENCES AND FURTHER INFORMATION

KonMari Method

The KonMari Method is a way of tidying and sorting out your possessions with a view to living a more minimalist lifestyle. It was developed by Japanese author Marie Kondo.

Official site: www.konmari.com

Level 10 Living

The idea of Level 10 living is that we strive to improve our wellbeing in all the different areas of our life.

The Wheel of Life idea (drawing out your levels in a circle) was first created by Paul J Meyer for Success Motivation International. It was further popularized by Hal Elrod in *The Miracle Morning*.

Printed in Great Britain
by Amazon